101 Adorable Breeds Dogs

Rachael Hale McKenna

世界の
美しい犬
101

写真：レイチェル・ヘイル・マッケナ

動物写真家としてのキャリアを通して、大きな犬、小さな犬、シャイな犬、社交的な犬、洗練された犬、だらしない犬、といったあらゆる種類の犬たちに出会ってきたわたしは、とてつもなく恵まれていると思います。もともと犬好きではありましたが、おかげでこの魅力的な生き物に対する愛着と尊敬の念が、より一層深まったのです。これまでに撮影した1匹1匹は、それぞれどんな犬種だったとしても、世間で言うところの「不完全」だったとしても、彼らそのものの存在自体が完全なまでに個性的でした。ちょうど犬たちが自分の飼い主の外見を気にしないのと同じように、犬に関して本当に肝心なのは中身で、経験から言うと、それはたっぷりの愛情と魅力につきます。

本書は完璧な図鑑というわけではありませんが、愛らしい犬たちをまとめ、人気の高い品種を幅広く掲載してます。犬を飼おうとしている人にとっては、お役立ち情報を見つけられるかもしれません。また、犬好きの友人へのプレゼントにぴったりかもしれません。本書を手に取る目的が何であれ、わたしが撮影時に味わったのと同じくらい、1枚1枚の写真を大いに楽しんでいただけると幸いです。

レイチェル・ヘイル・マッケナ

Contents

Hound 5
ハウンド（狩猟犬）

Herding 33
ハーディング（牧畜犬）

Working 57
ワーキング（使役犬）

Sporting 81
スポーティング（銃猟犬）

Non-sporting 117
ノンスポーティング

Terrier 147
テリア

Toy 171
トイ

Miscellaneous 201
その他の種類

Index 222
索引

Hound
ハウンド（狩猟犬）

1.
Afghan Hound

アフガン・ハウンド

アフガン・ハウンドは、貴族のように凛としていてどこかとっつきにくい雰囲気もあるが、非常に忠誠心が強く、愛情深い気質をしている。かなり古い時代からの犬種で、古代エジプトにも存在していたと考えられており、アフガニスタン北部の洞窟には、4000年以上も前のものとされるアフガン・ハウンドが描かれた絵画も残されている。万能で、スピードや敏捷性に加えてスタミナもあることから、かつてはアフガニスタンで羊番や猟犬として使われていた、上品なサイト・ハウンド【訳注：優秀な視覚と敏速な動きで獲物を追い詰める獣猟犬のグループ】種だ。オオカミ、ジャッカル、マーモット【訳注：Marmota 属の齧歯類の動物の総称。モルモットとは別のもの】やユキヒョウを仕留める名人だった。アフガン・ハウンドが初めて西欧諸国にもたらされたのは 19 世紀のことで、現在では、気高く荘厳な美しさで知られる高級なペットとなっている。「犬の王様」と呼ばれることも多い。

外見：体高が高め細身の体格で、頭部は面長で洗練されている。長くなめらかな冠毛（頭頂の髪のふさ）に独特な被毛スタイル、突き出した寛骨（骨盤の壁を形成する左右1対の骨）、大きな足、アーモンド形の黒い目が、エキゾチックな印象を作り出している。

毛色：さまざまな色のパターンがあり、顔と耳のフリンジ部分が体より濃い色をしていることが多い。

2.
Basenji

バセンジー

賢く優美で、上品で軽い身のこなしのバセンジーは「吠えない犬」として広く知られていて、その俊敏さと狩猟能力に加え、無口なところが珍重されている。古代エジプト時代にはすでに存在していたことがわかっているが、西欧の人々に発見されたのは、19世紀後半のアフリカでのことだった。洗練され、均整のとれた筋肉構造のおかげで、すばやくしなやかな動きができるバセンジー。そのような体の特性と自立心旺盛で勇敢な性格が合わさり、優秀な狩猟犬となった。狩猟中は静かにしていられる点が評価されているが、実際はすばらしい音の表現手段を持ち合わせていて、うれしそうにヨーデルを歌うような声で有名だ。見知らぬ人とは打ち解けにくいが、心を許した人に対しては優しく穏やかで、子供たちも愛情を込めて守ろうとする。潔癖な習慣があり、猫のように自身を毛づくろいすることでも知られている。

外見：しわのある額が特徴的な、短毛の中型犬。アーチを描く首と付け根が高い位置にあるカールした尾が、その優雅で利発的な印象をより一層強くしている。背中が短く軽快な体つきのため、体長の割に体高が高く見える。走る際の、すばしっこくて無理のない脚の動きで知られていて、その様子は全速力の競走馬のようだ。

毛色：チェスナット・レッド（赤茶色）、ピュア・ブラック、ブラック＆タン（褐色）、チェスナット・レッドに黒の縞のブリンドル【訳注：ブリンドルとは、地色に別の色の縞模様が入った毛色】など、さまざまなパターンがあるが、足・胸部・尾先にホワイトが入る。脚やブレーズ【訳注：頭頂部近くからマズルにかけて入るマーキング。通常ホワイト】、首まわりも白くなることもある。

3.
Basset Hound

バセット・ハウンド

気立てはいいけれど少し頑固なところもあるバセット・ハウンドは、フランスに起源を持ち、その名前も「低い」という意味のフランス語の形容詞「bas」に由来している。長きにわたってヨーロッパ中で人気が高く、主に狩猟犬として使われていた。他の狩猟犬との違いは、ベルギーのサン・テュベール修道院の修道士たちによって改良されたと考えられている、小柄な点だ。そのため、バセット・ハウンドは徒歩で追いかけやすいのである。ブラッドハウンドに次ぐ優れた嗅覚とも言われ、地面に近づいて臭跡を追うことができる低い体高と長い鼻を持っている。そのような体のサイズと構造のおかげで、密集した茂みの中でも簡単に動き回ることができる上、スタミナと決断力があるので、獲物（主にウサギやノウサギ）を追う長距離移動も可能だ。しとやかで従順な、愛情深くほがらかな性格で子供たちとも仲よくできるため、よき家族の一員となる。

外見：短い脚とがっしりした骨格に、大きな胸部と肺を持ち合わせた、狩猟犬にふさわしい体格。短くなめらかな毛にたるんだ皮膚と、大きすぎる耳に垂れ下がったまぶたのせいか、ちょっぴりものさびしくも見える。

毛色：一般的には、ブラック＆ホワイト＆タン、またはレモン＆ホワイトが多い。

4.
Beagle

ビーグル

賢く活発で陽気なビーグルは、その優れた狩猟能力と人なつっこい気質で知られている。この品種の初期の歴史についての確実な史料は存在しないのだが、古代ローマの時代以前に英国に伝わった猟犬の一群が、サイト・ハウンドとセント・ハウンド【訳注：優れた嗅覚で獲物の臭いをたどり追跡する獣猟犬のグループ】両グループの基盤を築いたと考えられている。ビーグルは人間と仲よくなるのが得意で、よき家族の一員となる。子供たちとの交流も好きで、人の心をつかむ茶目っ気と明るさもあり、時に騒がしくもある性格だ。また、手入れのしやすい被毛とコンパクトなサイズ、珍しく犬特有の匂いも少ない、といった飼い主にとってうれしい利点もある。

外見：がんじょうでコンパクトな体格だが、サイズは小さめ。強靭な前脚と堅く引き締まった足の持ち主で、体高は平均33cmから40cmほどである。

毛色：さまざまな色のパターンがあるが、最も多いのがブラック、タン、ホワイト3色の組み合わせであるトライカラー。タン＆ホワイト、またはレモン＆ホワイトになることもある。

5.
Bloodhound

ブラッドハウンド

非常に愛情深くてものわかりがよく、思いやりのあるブラッドハウンド。純血を維持するために慎重に繁殖されたため、狩猟対象ではなく、品種の貴族的な性質を反映した「ブラッド（純血）ハウンド」という名前がつけられた。この古い歴史を持つ犬種の始まりはローマ帝国時代までさかのぼるとされ、当時、ブラッドハウンドの祖先たちは、他の追随を許さない嗅覚と強力なスタミナで名高かったという。1805年には、英国の警察によって初めて、ブラッドハウンドの嗅覚追跡能力が試された。それから、その追跡能力の正確さは数々の法廷で認められ、法執行機関からの高い評価は現在でも揺るぎないものがある。疲れを知らない働き者で、慈愛に満ちたおだやかなブラッドハウンド。いくぶん慎重なところはあるが、子供たちや他のペットとの交流も楽しむ。また、防御欲がとても強いため、番犬にも向いている。

外見：他のほとんどの猟犬よりも大きく力強い、セント・ハンティングに最適な体格。胸底が深いため肺活量も多く、大きくたれた耳が匂いを拾い上げ、よく開く大きな鼻孔に届きやすくしていると考えられている。皮膚は触ってみるとうすくたるんでいて、頭部や首のまわりは深いしわとなっている。

毛色：典型的な例がツートーンカラーで、ブラック＆タンかレバー＆タンの組み合わせ。胸部、足、尾（または後尾部）が白くなることもある。

6.

Borzoi

ボルゾイ

ロシアが起源のボルゾイは、貴族の狩猟犬として何世紀にもわたって繁殖されていた。長距離走型の狩猟犬は13世紀チンギス・ハーンの時代には存在していたと言われていて、ボルゾイに関しては、11世紀にさかのぼる記述も残されているようだ。もともと「ロシアン・ウルフハウンド」として知られており、アラビアン・グレーハウンドと、厚い被毛を持つロシアの古代種の交配により誕生した。オオカミ猟のために作出されたので、獲物を捕まえて離さないでおけるがんじょうな首と強いあごに、特に重きが置かれている。嗅覚よりも視覚に頼るボルゾイは、とんでもないスピードで走ることが可能で、狩猟時には立派な度胸と敏捷性を見せてくれる。1860年代、狩りは貴族階級層お気に入りのスポーツで、100匹以上で群れを成すボルゾイの狩猟チームを見かけるのも珍しくなかったという。現在でも野生の獲物を制するために使われたりするが、その天性の狩猟能力よりもむしろ、貴族のような美しさと鋭い知性が珍重されている。人間との交流も楽しみ、特に子供たちとよくじゃれあう温和な気質の持ち主だ。

外見：優雅で洗練された印象のボルゾイ。よく発達した筋肉質の体格で、体高が高い。細く長い頭部がわずかにアーチを描く力強い首によって支えられ、傾斜した肩部とガッチリした胴体につながっている。

毛色：あらゆる色と組み合わせがある。

7.

Dachshund

ダックスフンド

快活で賢く、勇敢なダックスフンド。主にアナグマ猟のために、5世紀からドイツで繁殖されてきた犬種だ。300年前に残されたいくつかのイラストには、胴体が長く体高の低い、ハウンド種のような耳をした犬に追われるアナグマが描かれている。この犬の狩猟犬としての役割に関連付けて、最終的にダックスフンド（「Dachs」がアナグマ、「Hund」が犬という意味）と名付けられ、テリア【訳注：害獣退治や、キツネやウサギの狩りに用いられる猟犬の総称】の気質と体格に、ハウンド【訳注：獲物の追跡や追い詰める際に用いられる獣猟犬】の追跡能力を持つ犬種として知られた。ダックスフンドには、「スムース」「ロング」「ワイヤー」の、3種の被毛パターンがある。ダックスフンドの開発当初、ドイツのブリーダーたちが異なる被毛パターンの交配が有害だと気づいたため、それは禁止されていたが、スタンダード・サイズとミニチュア・サイズは後になって交配された。ダックスフンドは、頭がよく活発で度胸もあり、献身的で人なつっこい家族の一員となる。

外見：バランスが取れた体格で、体高が低い。短い脚に、強靭な前四分体と前脚、長い胴体が特徴的。どんなバリエーションだとしても頭部がくっきり際立ち、自信に満ちた知的な表情を見せる。

毛色：あらゆる色のバリエーションがある。

8.
Greyhound
グレーハウンド

容姿端麗なグレーハウンドは、一般的に知られている純血種の中で最古の犬種と考えられている。また、古代の彫刻作品や文学で描かれた犬たちは現存のグレーハウンドと同じ種類だ、ともされており、その歴史は、紀元前2900年頃のエジプトまでさかのぼることができる。当時の墓所には、シカやシロイワヤギを攻撃するグレーハウンド型の犬の姿が彫られていたようだ。紀元前43年から西暦17年の間には、ローマの詩人オウィディウスが、この犬種に関する包括的な記述を残していたという。このような史実の数々が、多くの大陸にわたってグレーハウンドの名を知らしめ、シカからウサギ・キツネにいたるあらゆる獲物を捕まえるハンターとして、称賛されていたことを裏づけている。しなやかな筋肉質で敏速な上、遠くまで見通せる視力を備えたグレーハウンドは、ものすごい速さで走破できる体のつくりをしたハンターだ。コーシング【訳注：獲物を匂いではなく視覚によって追わせるもの。特にグレーハウンドを使ったウサギ狩り】や競技レースの人気が急速に高まった19世紀、グレーハウンドはそれらの競技に好ましいレーサーとなり、レースに使われた機械じかけのおとりとともに、そのイメージを歴史上に印象づけた。卓越した天性の追跡のセンスがあるため、とても活動的なペットとなる。性格は、冷静で優しく、極めて誠実で非常に情愛が深い。

外見：均整のとれた筋肉質の胴体と強靭な脚を持つ、がんじょうな体のつくり。長い頭部と首が、この犬の高速な走りと広い歩幅に、計り知れないスタミナを一層際立たせている。

毛色：さまざまな毛色のパターンがあるが、ブラック、ホワイト、レッド、ブルーが最も人気が高い。

9.
Harrier Hound

ハリアー・ハウンド

陽気で優しく社交的なハリアー・ハウンドは、人との交流を楽しみ、冒険を好む犬である。13世紀のイギリスに起源を持ち、ノウサギ狩りで活躍した。非常に発達した嗅覚を持つ精力的な働き者で、群れを成して獲物を追い、徒歩で追いかけることができる点が人々に気に入られていた。数え切れないほど多くの人々に飼われていた犬で、ハウンド犬の群れを伴う狩り「スクラッチ・パック」においての所有率が高かったため、後に貧乏人の犬としても知られることとなった。サザン・ハウンドに少しグレーハウンドの血を加えて作出されたのでは、という見解もあるが、ハリアーは品種改良によって小型化され繁殖されたフォックスハウンドの小型版、という説が広く信じられている。よくはしゃぎ人なつっこい性格、というのは誰もが納得するところだ。他の犬たちともうまくやっていくことができ、人でも犬でもその両方が一緒でも、大勢の中で楽しく過ごせるタイプ。加えておおらかな気質もあるので、子供にとっても格好の遊び仲間となる。

外見：群れを成して狩りを行うセント・ハンティングに必要なすべての能力を備えた、均衡の取れた筋肉質の体格で、その卓越したスタミナと強さがにじみ出ている。実質的には、イングリッシュ・フォックスハウンドの小型版。

毛色：ハウンド・カラー（ホワイト＆ブラック＆タン）のさまざまなバリエーション。

10.
Irish Wolfhound

アイリッシュ・ウルフハウンド

古い歴史を持つグレーハウンドの変種とも言われ、全犬種の中で最も体高が高いアイリッシュ・ウルフハウンド。昔のアイリッシュ文学ではウルフドッグやアイルランドのグレート・ハウンドと称され、かつては野生のオオカミやイノシシ、大きなアイリッシュ・エルク（ヘラジカ）の狩猟をする、優しい巨体のハンターとして知られていた。もっぱら貴族階級に飼われていた犬種で、というのも、体が大きいため食事量も多く食費がかさむため、小作人たちがアイリッシュ・ウルフハウンドを養うのは実質的に不可能だったのである。大型犬向けの獲物が減少していったのに伴い、この犬種を絶滅から救ったのは、ジョージ・A・グレアム大尉という人物の功績だと考えられている。彼は、1862年に繁殖計画を開始し、その23年後に初めてアイリッシュ・ウルフハウンドのスタンダード（犬種標準）の原型となる犬を誕生させた。大きな体格で怖そうに見えるかもしれないが、とても優しい性格で疑うことを知らないため、警護や番犬といった役割には全く向いていない。その代わり非常に従順で、飼い主といつも一緒にいるのが大好きだ。

外見：全犬種一の体高を誇る、巨大なアイリッシュ・ウルフハウンドは、とても堂々とした風貌だ。力強さと敏捷性の両方を兼ね備えた、筋肉質だけれど優美な体形。しっかり支えられた頭部とかなり長い首が、わずかにカーブした尾によって調和を保たれている。

毛色：グレー、ブリンドル、レッド、ブラック、ピュア・ホワイト、フォーン、またはディアハウンドに見られる色（ダーク・ブルー・グレー、イエロー、レッド・フォーンでブラックの斑点があるもの、など）。

11.
Rhodesian Ridgeback

ローデシアン・リッジバック

ローデシアン・リッジバックは、南アフリカ原産として知られている犬種である。昔の南アフリカの文学作品では、背筋に沿って隆起した部分のある、半野生の土着の狩猟犬が伝えられている。16〜17世紀には移民たちが、グレート・デーンやマスティフ、グレーハウンドにテリアといった、さまざまな新しい犬種を南アフリカへ持ち込んだ。これらの犬種が、土着犬たちと自然に交配され、今日わたしたちが知るところのローデシアン・リッジバックの原種が誕生したのだ。1870年代には2頭のリッジバックがローデシア（アフリカ南部の旧英領地域）に持ち込まれ、そこでライオン猟競技において極めて高い能力を示し、その名を轟かせた。1922年には愛好家たちが犬種のスタンダードを確立し、ローデシアン・リッジバックという名前が授けられた。アフリカン・ライオン・ハウンドという名でも知られており、リッジバックは単なる別格の狩猟犬というだけでなく、それ以上の存在となっている。賢く勇敢で抜け目のない性格で、飼い主にとことん尽くし、多大なる忠誠心と優しさ、愛情を示してくれる。

外見：威厳があり、均整のとれたたくましい筋肉質の体格で、早く走れる上に持久力も高い。背筋に沿って隆起した部分の毛が、他の部分の短く濃い被毛とは逆の方向に生えているのが特徴的。

毛色：ライト・ウィートン（うすい小麦色）からレッド・ウィートン（赤みがかった小麦色）の色合いで、胸部とつま先にホワイトのマーキングがある。

12.
Saluki
サルーキ

気品あふれるサルーキは、家庭犬として最古の品種のひとつだと考えられている。サルーキに似た犬が描かれた最古の彫刻として、現在のイラク南部に存在したシュメール帝国の遺跡で発掘されたものが知られていて、その時代は紀元前7000〜6000年頃にさかのぼる。サルーキはそこから、エジプト、ペルシア、インド、アフガニスタンへと渡り、「エジプト王家の犬」とみなされていた。この犬種はとても高貴だったので、よくミイラにもされていたという。とてつもないスピードに定評があり、ガゼルのサイト・ハンターとしての才能もあった。非常に高価な犬として扱われたため、ヨーロッパの有力者たちへの贈り物とされることも多く、12世紀頃にようやくヨーロッパへ持ち込まれた。しかし、イギリスで見られるようになったのは1840年代になってからのことである。イギリスでは、ペルシャン・グレーハウンドとして知られ、キツネやノウサギ狩りに使われた。貴族のような外見にしっくりと相まった、広い範囲を遠くまで見通すようなまなざしに、その並外れた視覚がはっきりと表れている。華奢な体形だが、タフで忍耐強い性格で、信頼する相手に対してはとことん忠誠を尽くすことで知られている。

外見：均整のとれたほっそりした体格で、脂肪がほとんどないが、太ももの筋肉はたくましく、脚が長い。気品としとやかさに加え、俊足の雰囲気がにじみ出ている。

毛色：ホワイト、クリーム、フォーン、ゴールド、レッド、グリズル【訳注：白と黒が混じり合い、ブルー・グレー（青灰色）あるいはアイアン・グレー（灰白色）のような色合いに見える被毛】&タン、トライカラー（ホワイト&ブラック&タン）、ブラック&タンなど。

13.
Whippet

ウィペット

美しく優雅なウィペットは、この体重の家庭犬の中では最速のスピードを誇り、最高時速 56km が記録されている。ブル・ベイティング【訳注：中世にイギリスで流行した、鎖でつないだ雄牛に犬をけしかけて、どの犬が最初に牛の鼻先にかみついて殺すかを競う賭け事もしくは見せ物】や闘犬ショーといった残酷な競技が人気を失い、新たな娯楽が求められた時代に、競技用として繁殖された犬である。ウィペットを走らせるのに使った、賞として与えられるウサギに咬みつく動作にちなんで、当初は「スナップ（咬みつく）・ドッグ」と名付けられ、この役目における純粋な狩猟本能をストレートに表した「貧乏人の競走馬」というニックネームまでついた。このような不名誉な歴史もあるが、とても洗練された優雅な風貌をしている。エネルギッシュで元気な見た目とは対照的に、家ではおとなしくて人当たりのいいところを見せるウィペット。凛々しく穏やかで友好的な性格によって、その卓越した狩猟能力が覆い隠されている。

外見：スピードと力強さに、優雅さと品位を兼ね備えた印象を放つウィペットは、まさに競技用の猟犬と言える。体の輪郭と筋肉の均整美が、短くなめらかな密生した被毛によって引きたてられている。頭部は細長く、ぱっちりとした瞳で知的な表情を見せる。

毛色：単色や数色の混色など、さまざまなパターンがある。

Herding
ハーディング（牧畜犬）

14.
Australian Cattle Dog

オーストラリアン・キャトル・ドッグ

誠実かつ勤勉で、強力な保護本能を持つオーストラリアン・キャトル・ドッグ。イギリスからオーストラリアに持ち込まれたワーキング・ドッグ（使役犬）たちの交配種と、土着犬のディンゴ【訳注：豪州で野生化した赤茶色の毛がふさふさした犬】の異種交配によって作出された犬種である。1840年頃、ブリーダーたちは、ディンゴとハイランド・コリー（ブルー・マール）の交配に成功する。この犬たちが素晴らしい働き手だと判明したことが、輸入されたダルメシアンとの交配を進めるきっかけとなり、馬の中でも怖がらず主人にも忠誠をつくす、ブルーやレッドの小斑が入った被毛を持つ犬が生まれた。その独特の被毛は、今日のオーストラリアン・キャトル・ドッグの特徴として広く知られている。その後も、より優秀なワーキング能力を求めて改良が続けられる中で、牧羊犬のブラック・アンド・タン・ケルピーとも交配された。この過程で頭角を現したクオリティの高い子犬たちが、現存種の直系として認められている。その結果、ディンゴのように活発で小型の、ダルメシアンのように誠実で優しい、ケルピーのように勤勉な、理想の牧畜犬が誕生したのである。現在でも農村に不可欠のオーストラリアン・キャトル・ドッグは、その度胸と知性、献身的愛情が高く評価されている。

外見：とりわけ広いエリアでも狭い場所でも、あらゆるサイズの農地で働けるように改良されたため、コンパクトで力強い体のつくりである。たくましい筋肉が特徴的な、均衡がとれた体形で、おどろくほどすばしっこい。

毛色：他の犬種では決して見られない、珍しいマーキングで有名。色はスペックル（斑入りの）・ブルーかスペックル・レッドのどちらか。

15.
Australian Shepherd
オーストラリアン・シェパード

忠誠心の高さと知性、耐久力で知られる中型犬のオーストラリアン・シェパードは、その名前に反して完全にアメリカ生まれの犬である。この犬の先祖は、フランスとスペインの間にあるバスク地方に起源を持ち、1800年代にバスクの羊飼いによってオーストラリア経由でアメリカに持ち込まれたと考えられている。愛着を持って「オージー」と呼ばれるオーストラリアン・シェパードは、アメリカ西部の牧場主たちのお気に入りであった。適応能力と気さくな性格に加え、訓練の飲みこみが早いことから活躍の場が広がり、現在でも牧畜犬として重宝されている。盲導犬やペットセラピー犬、薬物検出犬、捜査犬や救助犬としても評価が高い。

外見：アスリートのような均衡がとれた体格で、機敏な動きを見せる。体高よりも体長が若干長く、ミディアムロングの被毛で覆われている。

毛色：ブラック、ブルー・マール【訳注：青みを帯びたグレーの地色にブラックの斑。色の濃い斑点が入った大理石模様の被毛を、マールという】、レッド、レッド・マールなど、さまざまなバリエーションがある。顔や胸部、脚にホワイトまたはタンのマーキングが入ることも。

16.
Bearded Collie

ビアデッド・コリー

イギリス最古の犬種のひとつであり、元気いっぱいでのんきなビアデッド・コリーは、コンパニオン・ドッグ（愛玩犬）と使役犬、両方の目的で繁殖された。親しみをこめて「ビアディー」と呼ばれ、ハイランド・コリー、またはマウンテン・コリーやヘアリー・モード・コリーという名でも知られている。多くの毛むくじゃらの牧羊犬たちと同じく、この犬種も中央ヨーロッパのマジャール・コモンドールの系統で、そこからがんじょうで活発で敏捷な牧羊犬へと改良されたと考えられている。ヴィクトリア王朝時代の高い人気をピークにいったん絶滅しかけたが、優秀な牧羊犬としてこの犬に一目置いたスコットランドのピーブルズシャーの羊飼いたちによって、生存を保たれた。聡明で自信にあふれたビアディーの人気は、時とともに着実に回復し、今日では愛すべき家族の一員として高く評価されている。

外見：筋肉質でたくましく、引き締まった長い胴体を持つ中型犬。好奇心たっぷりの、いきいきとした表情を見せる。特徴的なミディアムロングの毛むくじゃらの被毛とひげを備えている（bearded〈ひげを生やした、の意味〉）ことから、その犬種名がついた。

毛色：ブラック、ブルー、ブラウン、フォーン、スレート・グレーやさまざまな色合いのグレーの、いずれかの色で誕生し、ホワイトのマーキングが入る場合もあり、毛色は年齢とともに明るめに変化する。ホワイトのマーキングは、額にブレーズとして、またはスカル（頭蓋）や尾先、胸部、脚や足、首のまわりに現れることもある。

17.
Border Collie

ボーダー・コリー

自立心にあふれ理解力が高く、計り知れないスタミナと持久力を備えたボーダー・コリーは、世界トップクラスの牧羊犬として知られている。仲間に対しての愛情が深く、その保護本能は主人の羊の群れを世話する時に活かされる。イングランドとスコットランドの境界辺りに起源を持つことで知られているのだが、正確な歴史ははっきりされていない。しかし、スコットランドの方言である「コリー」という言葉が、険しいスコットランドの風景との直接的なつながりを裏付けている。ヴィクトリア女王の寵愛を受け、コンパニオン・ドッグとしての人気が次第に高まっていたが、1876年にイギリスでシープドッグ・トライアル（牧羊犬コンテスト）が始まった際、従順で賢く運動神経のいいボーダー・コリーに観客が度肝を抜かれ、一流の牧羊犬としての地位を取り戻した。

外見：身体能力の高い中型犬で、通常はやや長めの被毛に覆われている。頭部はかなり幅広で、用心深く知的な顔つきをしている。

毛色：ブラック＆ホワイトの組み合わせが圧倒的に多いが、ブラック、トライカラー（ブラック＆タン＆ホワイト）や、レッド＆ホワイトの混色も一定数で見られる。ブルー＆ホワイト、レッド・マール、ブルー・マール、オーストラリアン・レッドやセーブル（明るい褐色の地色に毛先が黒い被毛が重なる毛色）は稀なパターン。

18.
Briard
ブリアード

「毛皮にくるまれたハート」と評されることがあるブリアード。フランス古来の使役犬で、8世紀のタペストリーにもその姿を確認できる。もともとは牧羊犬として使われていたため、世話を引き受けたものを、捕食動物や侵入者から誠実に守るはずだ。その知性と学習意欲のおかげで極めて多才で、昔からさまざまな役割を担ってきた歴史がある。追跡や狩猟能力に加えて、鋭い聴覚と優れた記憶力に確固たる度胸を備えていたため、戦時下では、見張り番や捜索犬、救助犬としてだけではなく、パトロールする兵士たちの忠節な相棒として貴重な戦力となった。惜しみなくたっぷりと愛情が注がれると、それにしっかりと応じ、献身的にとことん忠誠を尽くしてくれる。コンパニオン・ドッグとして非常に人気が高く、穏やかで従順だが、遊び好きが高じてあばれ過ぎてしまうことも。見知らぬ人を警戒するので、番犬にとても向いている。

外見：上から下へ弧を描き、そっと目を覆っているぼさぼさの眉が特徴的で、たっぷりのひげと粗い質感の被毛が、ブリアードのいかつい印象を生み出している。筋肉質でたくましく、身体能力が安定しているため、優れた羊飼いの見本とも言える。それぞれの後脚にあるデュークロー（狼づめ）が、ブリアードの最大の特徴である。

毛色：ブラックや、さまざまな濃淡のグレーやタウニー（黄褐色）、またはこれらの色の組み合わせになることもある。

19.
German Shepherd Dog
ジャーマン・シェパード・ドッグ

忠誠心が高く、勇敢で賢いジャーマン・シェパード・ドッグ（アルザスの者という意味の、アルサシアンと呼ばれることも多い）は、優れた持久力と耐久力に、訓練意欲と労働意欲の高さで有名である。当初は羊飼いや農地で使われるドイツの牧羊犬として繁殖された犬が、今日では、誰もが見憶えのある、最も人気が高い犬種のひとつとなった。さまざまな役割において抜きん出ていて、盲導犬や薬物検出犬、捜索救助犬、警察犬や介助犬として、高く評価されている。非常に義理堅く、「ワンマン（ひとりだけになつく）」犬としても知られている。誰にでも気やすく好意を示すことはないのだが、いったん愛情を注ぎ始めると、その愛を一生貫くのだ。何事にも恐れることなく防御し、一定レベルの判断力に、高レベルの理解力や忍耐強さを見せる。

外見：筋肉質でたくましく、持久力やスピードを発揮したり、突発的で俊敏な動きをしたりするのに適した体のつくりをしている。体高よりも体長が長めの均整がとれた体格で、強靭な骨格と、角張らずなめらかなカーブを描く輪郭の持ち主。被毛はミディアム・ロングかロングのダブル・コート。

毛色：さまざまなバリエーションがあるが、最も一般的なのが、ブラック、ブラック＆タン、セーブルである。

20.
Old English Sheepdog
オールド・イングリッシュ・シープドッグ

優しく聡明で、子供たちにもたっぷりの愛情を持って接するオールド・イングリッシュ・シープドッグ。世話をする家畜の行動を優しくゆっくり促す能力で、まさに生粋の牧羊犬として知られている。それほど古い犬種ではないけれど、この名前からも想像がつくように、150〜200年程前には確認されていたようだ。19世紀の初め頃に、イングランド西部で繁殖されていて、専門家の多くは、その血統においてスコッチ・ビアデッド・コリーかロシアン・オフチャルカ（サウス・ロシアン・シェパード・ドッグ）のいずれかが重要な役割を果たしていたと考えている。当初は、市場へ移動する羊や牛の群れを追うために使われていたが、理想的な家庭犬にもなる性格だ。冷静で友好的な上に順応性が高く、訓練もしやすいので、家庭生活に適しているのである。

外見：すぐにオールド・イングリッシュ・シープドッグだと見分けがつく、たっぷりとしたふさふさの被毛。意外にも、他のどんなロングヘアの犬種よりも手入れが簡単だという。被毛の下には、がんじょうでスクエアのコンパクトな体が隠れている。犬というよりも熊のような、足を引きずった歩き方はこの犬種特有のもの。また、鳴き声がおどろくほど大きい。

毛色：グレー、グリズル、ブルーまたはブルー・マールのさまざまな色調に、ホワイトのマーキングが出ることも。または白地に、前述のいずれかの色のマーキング、というパターンもある。

21.
Pembroke Welsh Corgi

ウェルシュ・コーギー・ペンブローク

ウェルシュ・コーギー・ペンブロークは、原型のコーギー・カーディガンから分岐した犬種で、現在ではペンブロークの方が人気がある。コーギー型の犬の中で新しい方だと考えられていたが、もはや新参者ではない。12世紀初頭、織工であり有能な農場主でもあったフラマン人たちが、この犬種の先祖とともにウェールズに移り住んだ。彼らは、機敏で勇敢なペンブロークを牧羊犬としても使っていた。この犬種の家畜を追う能力はいまだに評価が高く、今日でも活用されている。手がかからず、賢くて用心深く優しいウェルシュ・コーギー・ペンブローク。フラマン人たちの農場の母屋では室内にいて、決まって暖炉の前で特等席を見張っていたという。1933年、ヨーク公（後のジョージ6世）が娘のエリザベス王妃（後のエリザベス女王2世）にペンブロークの子犬をプレゼントし、それ以降イギリスでの人気が高まった。現在では、ペットとして大変人気があり、暖炉のそばで見張りをしている姿も健在である。

外見：しっかりとしたがんじょうな体のつくりで、やや長めの胴体をしており、快活ではつらつとした表情を浮かべる。短く濃い、どんな天候にも耐えられる被毛の持ち主。

毛色：レッド、セーブル、フォーン、ブラック＆タンのいずれかで、脚・胸部・首・マズル・腹部・頭部にホワイトのマーキングが現れる場合もある。

22.
Puli

プーリー

1000年以上にもわたり、ハンガリーの牧羊風景に不可欠な犬として、その多才な能力と活力、俊敏性で名を知られていたプーリー。ハンガリーに移り住んだマジャール人の牧羊犬の流れをくんだ犬種と言われ、チベタン・テリアのように、16世紀にハンガリーが侵略された際に数多くの牧羊犬種が持ち込まれたため、もともとのプーリーは危うく絶滅しそうになっていた。その後プーリーの繁殖計画が開始され、ぼさぼさでくるくるの独特な被毛を持つ犬種が確立されたのは、20世紀に入ってからのことである。生まれ持った牧羊犬の素質があるため、愛情あふれる献身的な相棒として、室内でも丘の上でものびのびと過ごすことができる。また、番犬としても優れていて、元気がよく活発で一緒にいてとても楽しいので、家庭犬として完璧だ。

外見：ひと目でプーリーとわかる、毛むくじゃらで全天候型の独特な被毛（このような犬は他にいない）が特徴的。密生したおびただしい量の毛は、自然と縄のような形状になる。被毛の下には、中型でスクエアのコンパクトな胴体が隠れている。

毛色：単色のブラック、ラスティー・ブラック（さび色がかった黒）や、さまざまな濃淡のグレーやホワイトがある。

23.
Rough Collie

ラフ・コリー

スコットランドとイングランド北部が原産のラフ・コリーの先祖は、勤勉な牧畜犬で、当初は畜牛や羊を市場に連れて行くために使われていた。犬種名はおそらく、世話をしていた家畜のひとつで、「コリー」と呼ばれていたスコットランドの顔が黒い羊から派生したものだろう。19世紀より前の時代、コリー犬は厳密に言うと血統書付きではない使役犬だったが、1880年代には犬種のスタンダードが確立され、ラフ・コリーはボーダー・コリーのような他の牧羊犬種から切り離された。ヴィクトリア女王時代から人気が高く、その堂々とした気品あふれる雰囲気が称賛されてきた犬種である。誠実で愛情深く、特に子供たちとの親和力が高い。非常に賢いのでしつけやすく、最高の家族の一員となる。

外見：じょうぶで活発な、均整のとれた犬種で、たっぷりとしたライオンのような被毛を備え、まっすぐしっかりとした立ち姿を見せる。ほどよく幅広で深い胸部に、バランスのいい体格のラフ・コリーは、優美さと誇りの象徴とも言える。

毛色：セーブル＆ホワイト、トライカラー（ブラック＆ホワイト＆タン）、ブルー・マールが一般的。

24.

Shetland Sheepdog

シェットランド・シープドッグ

忠誠心が高くとても礼儀をわきまえるシェットランド・シープドッグは、最も完成度の高い訓練犬のひとつである。生まれつきよろこんで言うことを聞く、といった、きちんとしつけられた犬が何世代にもわたって発達させてきた本能を持つ犬種で、実際のところは使役犬であるコリーの小型版だ。スコティッシュ・ラフ・コリーとアイスランド・ヤッキンの流れをくむ血統だと考えられており、その姿は18世紀からほとんど変わっていない。シェットランド島の険しい環境の中で、羊の世話と保護のために改良された小さなサイズの体形は、離島に生息する数々の動物たちにも見られる特徴だ。生まれ持った防御欲に加え、その大きさと敏捷性で勢いよく優雅に対象を追いかけ回すことができるため、優秀な農場犬や狩猟犬となる。同時に、非常に強い忠誠心とつきない愛情で、正真正銘の家庭犬にもなる。また、もともと明るい性格なので、子供たちとの触れ合いも楽しみながら、誠実に守ろうとしてくれる。

外見：ラフ・コリーの小型版で、サイズに加えて被毛にも違いが見られる。胴体は小さく、釣り合いが取れているが、被毛は長くて粗くふさふさしている。このような特徴が愛らしい表情と相まって、あふれんばかりの魅力が放たれている。

毛色：セーブル、ブルー・マール、ブラックにさまざまな分量でホワイト＆タン（またはホワイトかタンのどちらか）のマーキングが入る。

Working
ワーキング（使役犬）

25.
Alaskan Malamute

アラスカン・マラミュート

迫力があり、凛々しく忠誠心が高いアラスカン・マラミュートは、北極地方のソリ犬の中で最古の犬種のひとつだ。古い文献に、アラスカ西北部の海岸沿いから戻った船乗りたちとともにやって来たという記録があり、それによると、この犬たちはマラミュートという地域の先住民イヌイット族のソリをひいていたようだ。後に、その地域名が犬種名となった。あるいは、その犬が白人入植者たちによって連れてこられた他の犬種と交配されたのかもしれない。ソリレース人気の高まりに伴いさらなる交配が行われ、より速く軽い犬が求められていった。アメリカでもソリレースが行われるようになると、スピードよりもマラミュートのスタミナと強さに重きを置いた、純血種復活への関心が高まり、純血種としては、1926年に認証されている。友好的で人との交流を楽しみ、愛嬌のあるアラスカン・マラミュート。ダイナミックで遊び好きな一方、誠実に尽くす性格のため、愛すべき仲間になってくれる。

外見：端整で凛々しい容姿で、強靭な肩にまっすぐな頭部、隙のないまなざしとシャープにとがった耳を備え、しっかりとした立ち姿を見せる。重い荷物を引っ張るのに最適な筋肉質の体は、あらゆるソリ犬の中で最重量を誇る。被毛は、濃く短い。

毛色：グレーからブラックまでの色合いか、セーブルとセーブルからレッドまでの色合いになる。下腹部、四肢、顔の一部がホワイトのマーキングで覆われている。

26.
Bernese Mountain Dog
バーニーズ・マウンテン・ドッグ

端麗で、優しく知的なバーニーズ・マウンテン・ドッグ。すぐに見分けがつく、トライカラーの長くなめらかな被毛の持ち主だ。スイス・マウンテン・ドッグ4種のうちのひとつで、地元ではベルナー・ゼネンフント（ベルンの山犬）という名で知られている。侵略してきたローマ人によって、2000年以上も前に番犬としてスイスに持ち込まれたバーニーズは、地元の人々が農作業のために繁殖させた。危険が潜む山道を進むのにうってつけのがんじょうさと敏捷性を兼ね備え、家畜を市場に追っていったり、荷車引きをしたりする犬として当時話題となったようだ。一時絶滅の危機に瀕したが、バーニーズをよみがえらせ存続を守るために献身的につくした、ひとりのスイス人愛好家フランツ・シュルテンライプの手により、1892年に復活。現在では、明るく賢い自発的な性格の、誠実で愛すべき仲間として広く受け入れられている。

外見：貴族のような雰囲気と、長くシルクのようなトライカラーの被毛が特徴的。がんじょうな骨格で、体高よりも体長の方が少し長い。生来の自信に満ちた風貌に加え、アーモンド形のダーク・ブラウンの瞳が表情豊かである。

毛色：ブラック、リッチ・ラスト（濃いさび色）、ホワイトからなるトライカラー。地色は真っ黒で、さび色のハイライトが、目の上、口角から頬と胸部のまわり、四肢と尾の裏側を囲むように入っている。ブレーズとマズル・バンド、胸部はホワイト。

27.
Boxer

ボクサー

護衛用として繁殖されたが、つきることのない遊び心と我慢強さを併せ持つため、献身的な番犬だけでなく、秘蔵の作業犬や家族の一員にもなるボクサー。ドイツで繁殖された中型犬で、もともとはマスティフ系の犬たちの血筋を受け継ぎ、また、ブルドッグの血統も汲んでいる。生来の防御力と勇敢さがドイツのブリーダーたちに気に入られ、当初はドイツ警察で使うために繁殖されていた。その後、ブリーダーたちは改良過程において苦労しながらも、本来の気質を保ちつつ、より魅力的なスタンダードを確立することに成功したのである。現在のボクサーは、生まれながらの保護本能はそのままに、無私の献身的愛情と忠誠心を兼ね備えている。利口でしつけやすく、卓越した勇敢さと心身の強さを見せてくれる。

外見：短い被毛に強靭な四肢と筋肉質の胴体を持つ、スクエアで中型の体格。よく整った頭部と、広く丸みのあるマズルが、ボクサーの最大の特徴である。ボクサーの体格には、一流の番犬・作業犬に特化して改良された強さや俊敏性、上品さといった、あらゆる資質が凝縮されている。

毛色：フォーンまたはブリンドルが一般的。下腹部、胸部、脚がホワイトになる場合が多く、顔にも白い部分が現れることもある。フォーンは、ライト・タンからマホガニーの範囲でグラデーションを成す。ブリンドルは、フォーンの被毛に細くはっきりとした縞模様が入る場合から、縞模様が多く現れる場合まで、さまざまなバリエーションがある。

28.
Bullmastiff

ブルマスティフ

知的で誠実なブルマスティフは、19世紀にイギリスの狩猟地を密猟者から守るために繁殖された犬種だ。闘争心に欠け鈍すぎるとされていたマスティフと、小さいけれどう猛すぎるブルドッグの交配によって誕生した。ブルマスティフは、その勇敢さもさることながら、スピードと敏捷性に加え、命令に応じての攻撃や、裂傷を負わせずに獲物を捕まえておく能力にも定評がある。彼らの知性と奉仕欲が、軍隊や警察での活躍にもつながっている。現在はペットとしての評価も高く、しっかりとしていて頼りがいのある、温かい気質で知られている。

外見：たくましく筋肉質で、濃い短毛のブルマスティフ。成犬の平均体高は65cmで、平均体重は54kg。長めの鼻と強靭なあごを備えた頭部は、古代ブルドッグを彷彿とさせる。

毛色：レッド、フォーン、ブリンドルのいずれか。

29.
Doberman Pinscher
ドーベルマン・ピンシャー

19世紀後半のドイツで、中型犬として護衛用と家庭用両方の目的で作出されたドーベルマン・ピンシャー。古い犬種で短毛の牧畜犬ロットワイラーと、ブラック・アンド・タン・テリア、ジャーマン・ピンシャー等の異種交配によって誕生したと考えられている。アメリカの愛好家たちによって改良が進められ、1900年頃に公式に認められた。理解力が高く、優れたスピードと体力を持つたくましいドーベルマン・ピンシャーは、刺激を受けると知能的にも身体的にも他を圧倒する。見知らぬ人を疑い、用心深く恐れも知らないため、番犬にとても向いている一方、誠実で従順なところもあるので、ひたむきで愛すべき相棒にもなる。

外見：中型で、堂々とした身のこなしを見せる、筋肉質のコンパクトな体格。はっきりとした力強い体のすじと落ち着いた表情、密生したなめらかな短毛のすべてが合わさって、極めて上品な雰囲気を漂わせている。

毛色：最も一般的なのは、ブラックに、目の上、マズル、のどと前胸、四肢、尾の下の部分がラスト（さび色）になるケース。レッド、ブルー、フォーンになる場合もある。

30.
Great Dane

グレート・デーン

優雅で上品な印象のグレート・デーンは、あらゆる犬の中でも、まさに巨体と言える犬だ。非常に古くからの犬種とされ、グレート・デーンに似ている犬が紀元前1121年もの昔の中国の文学作品でも見られたり、紀元前3000年頃のエジプトの墓にも巨大な犬が描かれたりしている。しかし、この犬種がドイツで作出されたのは、中世になってからのことだ。ヨーロッパ最強のどう猛なイノシシを捕まえるために繁殖されたグレート・デーンの原種は、著しく凶暴だったが、アメリカの愛好家がチャーミングで温厚な性格に改良し、1887年に初めてアメリカで紹介された。グレート・デーンの鋭い知能と防衛本能は、番犬としてよく知られている。また、人なつっこく誠実で頼りになるため、末長いつきあいを楽しむことができる。

外見：堂々としていて上品なグレート・デーンは、とてもじょうぶな整った体つきで、筋骨たくましい。歩幅が広く力強い流れで動くので、決してぎこちなくなることのない、きびきびした印象を与える。被毛は短く密生していて、つやがある。

毛色：ブリンドル、フォーン、ブルー、ブラック、マントル（マントをかけたような大きな斑が肩からボディーにかけて入る）、ハールクイン（白地に不規則なブラックの斑）がある。

31.
Neapolitan Mastiff
ナポリタン・マスティフ

古代の巨大な軍用犬の血を引き継いでいると考えられているナポリタン・マスティフは、モロシアンと呼ばれた犬を直系の先祖とし、アレキサンダー大王（紀元前356年〜323年）によって繁殖され、トラやライオン、ゾウに加え、人間とさえも戦わせる闘犬として使われた。現代のナポリタン・マスティフは、古代犬種的な厚くゆるんだ皮膚とデューラップ（しわになってゆるく垂れ下がったのどの皮膚）に、大きな体格を保持しながら、もともとは家屋や土地の保護犬として、イタリアで改良されてきたと考えられている。土地や財産を勇敢に守るナポリタン・マスティフは、とても忠誠心が高く、命令を受けた時のみ攻撃をしかける。家族の一員として健やかに成長する、落ち着いたおおらかな犬種である。

外見：巨大で骨太で、体重が70kg以上になることも。体中を覆うたるんだ皮膚と、たっぷりとしたしわとひだを蓄えた頭部に、大きなデューラップが特徴的。上品というよりも、よろよろと重そうな動きを見せる。

毛色：グレー（ブルー）、ブラック、マホガニー（赤褐色）やタウニーといった色のさまざまな色調の単色。ブリンドルになることもある。

32.
Newfoundland

ニューファンドランド

大きくて抱きしめたくなるほどかわいらしいニューファンドランドの最大の特徴は、思いやりがあり、人に対して優しい点である。原種が、ヨーロッパの漁師たちによってカナダのニューファンドランド島沿岸に連れてこられたと考えられていて、ハスキー犬の先祖と交配された可能性もある。陸上で荷馬車を引いたり、荷物を運んだりするのに使われたニューファンドランドは、優秀な水中犬でもあり、救助や網引きにも役に立っていた。水かきがある足のおかげで速く泳げる上、優れた耐久力とスタミナもあるため、生まれながらにして水辺の人命救助犬なのだ。このような仕事は知性と自信が要求されるが、つきることのない愛情も持ち合わせているので、選んでくれた家族に対して非常に忠実で献身的な態度を示す。

外見：大きくてバランスのいい、がっしりとした筋骨たくましい体格。少し油を含んだような肌触りの、厚いダブル・コートの被毛が、水中での活動に最適。

毛色：ブラック、ブラウン、ホワイトにブラックのマーキング、のいずれか。

33.
Saint Bernard

セント・バーナード

17世紀中頃から、スイスとイタリアの間を通過する旅人たちに休息場所を提供した、アルプス山脈の有名な宿坊で飼われていたと考えられているセント・バーナード。修道士たちの伴侶であり、施設の番犬であり、危険の潜む孤立した環境下でのかけがえのない捜索救助犬でもあった。過去3世紀にもわたって、強力な嗅覚によって2000人以上もの人命を救助し、19世紀中頃から後半までには世界的にもその名が知られるようになった。大きくて力がありどんな気候にも適応できる上、とても優しく愛情に満ちている。子供たちとも相性がよく、信頼できる性格で、家族の一員として、多才なコンパニオン・ドッグになる。

外見：筋肉質でたくましく、どっしりした頭部と大きな足を持つセント・バーナードは、背も高く巨体で、人目を引く出で立ちだ。奥まった位置にあるつぶらな瞳で、知的な表情を見せる。被毛は2種類あり、短毛はスムース・コートで、長毛はラフ・コート。

毛色：レッド、ブリンドル、ブラウン・イエローにホワイトのマーキング、またはホワイトにレッドのマーキングのパターンがある。

37.
Samoyed

サモエド

陽気で優しいサモエドは、「ラフィング・キャバリア（笑う騎士）」や「スマイリング・ドッグ」と呼ばれることもある。欧米に伝わったのは19世紀と比較的最近だが、異種交配のしっかりとした証拠は残されていない。氷で覆われたシベリア北部に住み着いた古代イランの民族、サモエド族のコンパニオン・ドッグの血を受け継いでいるとも言われている。この犬種は、羊を追い、ソリを引き、サモエド族に寄り添いながら、遊牧生活を送っていた。北極地方の環境に適応し被毛は純白になり、平たい足が氷の多い環境に完璧に順応した。働き者のサモエドは、北極や南極への数々の歴史的探検旅行でも活躍し、1911年のロアール・アムンセン（1872〜1928）【訳注：南極点と北極点に最初に到達したノルウェーの探検家】の探検隊にも同行していた。人間との長い付き合いの中で、「人間的な」理解力を発達させてきたサモエド。のんきで、まるで子供のような態度もとてもかわいらしい。お茶目でよくはしゃぎ、子供たちとの相性も抜群である。

外見：美しく上品なところもあるが、本質的には作業犬気質。たくましい筋肉質の胴体と深い胸、強靭な腰部を備えている。真っ白で厚い全天候型の被毛と、いつもほがらかな表情で、ひと目でサモエドとわかる。

毛色：ピュア・ホワイト、ホワイト・ビスケット、クリーム。

35.
Siberian Husky
シベリアン・ハスキー

持久力のあるソリ犬として広く知られている、シベリアン・ハスキー。アジア北東部のチュクチ族の作業犬の流れをくむ犬種で、3000年以上前から、もともとソリを引いたりトナカイの世話をしたりする目的で使われていたという。何でもこなせてがんじょうな上、適度なスピードで広大な土地を移動し、寒さの中でも何ともなしに軽い荷物を運ぶことができた。アラスカへ持ち込まれた19世紀までは純血を保っていたようだ。アラスカでのソリレースの人気とともにこの犬の人気も高まり、1939年にシベリアン・ハスキーという名で公式に承認されている。つきることのないスタミナと行儀のよさが買われ、アメリカ軍の北極探査や第二次世界大戦時の救助隊、バード少尉の南極探検でも勇ましく活躍した。凛々しく社交的で、見知らぬ人にも愛想よく接する。また、理解力が高く勤勉で、愛嬌もある性格なので、訓練されることも家庭生活も楽しむタイプだ。

外見：パワーとスピードと持久力の印象を放つ、中型でコンパクトな筋骨隆々の体格で、狼のような頭部が特徴的だ。注目すべきはアーモンド形の目で、さまざまな色のバリエーションがあり、片目がブラウンでもう片方がブルーになる、といったケースもある。

毛色：ブラックからピュア・ホワイトまで、あらゆる色のパターンがある。

Sporting
スポーティング（銃猟犬）

36.
American Cocker Spaniel

アメリカン・コッカー・スパニエル

「コッカー」のスポーティング・グループの中で最小とされている、アメリカン・コッカー・スパニエル。そもそもは、イングリッシュ・コッカー・スパニエルの慎重な繁殖から発展した犬種である。大きなグループとしての、スパニエル系の犬に関する文献が発見されており、それは14世紀という古い時代にまでさかのぼるものだった。スパニエル犬が「ウォーター（水中）」と「ランド（陸上）」というふたつのグループに分類されるようになったのもこの時期だったようだ。「コッカー」は、現在アメリカでは一番人気の純血種のひとつとなっている。「コッカー」という言葉は「ウッドコック（ヤマシギ）」という鳥の名前に関連している。というのも、スパニエル犬たちは、この鳥を茂みから追い出したり飛び立たせたりする（フラッシング）のが特に上手だったからである。コッカー・スパニエルは、その名前にも反映された能力――狩猟や追跡、撃ち落とした獲物を回収して持って来る能力――を買われ、繁殖されてきた。持久力を保ちながら、かなりのスピードを出すこともできる。家庭での理想的なコンパニオン・ドッグで、まわりをよろこばせることも大好きなため、その気質が「メリー（陽気な）」と評されることも多い。

外見：コンパクトでがんじょうな体格で、洗練された顔立ちと表情豊かな瞳に、だらりと垂れた耳が特徴的。イングリッシュ・コッカー・スパニエルとは、外見上ではっきりとした違いが見られる。マズルが短めで瞳がより丸く、毛量がたっぷりとしている方が「アメリカン」だ。平均体重は、8～13kgほどである。

毛色：コッカー種には数多くのバリエーションがあり、ブラック、ブラックにタンのポイント（斑点）があるもの、パーティ・カラー【訳注：白地に、1色または2色のはっきりした色斑があるもの】、ブラック以外の単色、などである。

37.
Brittany
ブリタニー

楽天的なこの犬種のブリタニーという名は、原産地であるフランスの地域に由来している。非常に古い犬種で、西暦150年という昔から存在していたと信じられているが、その繁殖過程の詳細記録は正確には残っていない。しかし、ウェルシュ・スプリンガー・スパニエルと似たような経歴をたどってきたと考えられていて、この2種が異種交配された可能性は極めて高く、両者の外見が似ていることからもその説明がつく。この犬が存在していた証拠は、ブリタニーが絵画やタペストリーで描かれるようになった17世紀に初めて現れた。ブリタニーだと思われる猟犬——小さなボブテイル（断尾）を持つ、獲物の場所を示したり撃たれた獲物を捕ってきたりするのが上手な犬——の記録が出てきたのは1850年のことである。1907年、エネルギッシュなブリタニーは犬種として認められ、生まれ持った狩猟能力に加え、適度なサイズと友好的な性格のため、その人気は上昇した。常に注意を怠らず、すぐに行動にうつれる心構えを持つ、陽気で優しい家族の一員となる犬だ。

外見：コンパクトで脚が長く、敏捷性とスピードを発揮するのに最適な体のつくり。特質上、尾がない場合と断尾されている場合があり、被毛は密生してウェーブがかっているか平たいかのどちらかである。

毛色：あらゆる色や色の組み合わせになり得るが、最も人気があるのはオレンジ＆ホワイトか、レバー＆ホワイト。各色混じり気がなくはっきり区別できる場合と、ローン【訳注：色のある地色にホワイトの毛が微妙に混じりあっている毛色】になる場合がある。

38.
Chesapeake Bay Retriever
チェサピーク・ベイ・レトリーバー

チェサピーク・ベイ・レトリーバーは、1807年のアメリカ北東部のメリーランド沿岸で難破したイギリスの船と関係がある、とされている。沈みゆく船から助け出された、2匹の子犬。それは、ニューファンドランド・タイプのオスとメスだった。水中で撃ち落とされた獲物を回収してくる能力が見事で、高く評価されたこの2匹から、チェサピーク・ベイ・レトリーバーが生まれることとなる。この2匹の子孫が、地元のレトリーバー（鳥を回収する犬）や、イングリッシュ・オッター・ハウンド、フラットコーテッド・レトリーバーやカーリーコーテッド・レトリーバーといった犬たちと交配されたという。その結果、チェサピーク湾付近の冷たい水の中でも俊敏性とスタミナを発揮したことで有名になった、この犬種が誕生したと考えられている。チェサピーク湾では、獲物を捕るためには時に厚い氷を分け入る必要もあったが、この犬は1日に100〜200羽ものカモを捕ってくることができた。賢く強い精神力だけでなく、忠実で献身的な伴侶となるチェサピーク・ベイ・レトリーバー。非常に優れた感覚の持ち主で、明るく楽しい性格も評判がよく、かけがえのない家族の一員になってくれる。

外見：活発で身のこなしが軽く、極寒の地にも適した体格。たくましく均衡のとれた体は、人目を引くとびきり上質な毛で覆われている。その被毛は生まれつき油分をたっぷり含み、粗く短いアウター・コートが、細く密生した羊毛状のアンダー・コートを覆っている。

毛色：ダーク・ブラウンから、色あせたタンやくすんだストロー・カラー（わら色）などの、ブラウン系の色。

39.
Curly-coated Retriever
カーリーコーテッド・レトリーバー

正確な起源ははっきりとしないものの、レトリーバー種の中で最古の歴史的な犬種とも言われているカーリーコーテッド・レトリーバー。16世紀のイングリッシュ・ウォーター・スパニエル、セント・ジョーンズ・ニューファンドランドなどの交配種の血を受け継いできたと考えられており、19世紀の終わり頃にはプードルとの異種交配も行われた。イギリスの狩猟番人お気に入りだったこの犬種は水中では負けなしで、生まれ持った守備能力とスピードや敏捷性の高さに加え、度胸と底なしの体力によってその名が知られていた。友好的で愛情深いカーリーコーテッド・レトリーバーは、人間とたわむれるのも大好き。活発で利口で、とても楽しく穏やかな性格だ。忠誠心が高く、まわりを積極的によろこばせようとするので、すぐに仲よくなれる。

外見：特徴的なウォータープルーフの、ゆるみなく縮れた被毛のためすぐに見分けがつく。この巻き毛が、胴体から尾にいたるまでの大部分を覆っているが、顔や前脚の前面と足は、なめらかで短い直毛で覆われている。自信に満ちた貴族のような雰囲気をまとったがんじょうな体のつくりで、他のレトリーバー犬よりも背が高い。

毛色：ブラックかレバー。

40.
English Cocker Spaniel
イングリッシュ・コッカー・スパニエル

最古のスパニエル種のひとつとされるイングリッシュ・コッカー・スパニエルは、楽天的で陽気な気質で有名だ。17世紀まで、すべてのスパニエル犬がひとつのグループという扱いだったのが、1892年に初めて、イングリッシュ・ケネル・クラブが狩猟能力やサイズによってそれぞれ個々の犬種を承認するに至っている。これより前に、スプリンガー・スパニエルとコッカーが同時に生まれてくることもあったが、その違いはサイズのみであった。イングリッシュ・コッカー・スパニエルは、スペインのスパニエル犬の原型の血筋を組んでいると考えられていて、ヤマシギを見つけ出して飛び立たせる狩猟犬の最高峰だった。力強い体格は、素早く走破し、獲物を回収してくるために密集した茂みの中を駆け抜けるのにうってつけである。労働意欲がある犬で、従順で機敏な動きを見せ、何かを探したり忙しなく動き回ったりしながらも、進んでものを運んでくれる。また、エネルギーに満ちあふれ、生来遊ぶことが好きで優しいので、よろこんで家族の一員にもなる。

外見：均整のとれたコンパクトな体形。低めの位置に耳がついていて、毛は長く、優しく和やかな表情を見せる。

毛色：ブラック、レバー、さまざまな色調のレッドといった単色に加え、ブラック＆タン、レバー＆タンといったバリエーションが見られる。また、パーティ・カラーとなり、単色にはっきりとしたマーキングや、ローンまたはティッキングが入る場合もある。

English Setter
イングリッシュ・セター

品があって堂々としているイングリッシュ・セターは、古代スポーティング犬種の子孫である。14世紀から、もともとは腕のいい鳥獣犬として繁殖されていて、その外見よりもむしろ狩猟中の作業能力が珍重されていた。スパニッシュ・ポインター、大型のウォーター・スパニエル、スプリンガー・スパニエルの交配種だと考えられており、その結果、広大な田園地域で獲物を探し出し、ポインティング（獲物の方を向いて鼻・背・尾を一直線にして動きを止めて獲物の場所を指し示す）能力が高いことで知られた、優れた猟犬が誕生したのである。現存のセターは、19世紀の熟練された繁殖計画によって洗練され、現在では、とても献身的で気立てのいい友好的な犬として、室内でも野原にいる時と同じようにくつろぐ姿が見られる。家族の一員としての生活を楽しみ、子供たちとも仲よくできる、優しく穏やかな愛すべき犬である。

外見：中くらいの背丈で、なめらかな輪郭の体つきをしている。平らで長く、シルクのような被毛の持ち主。

毛色：オレンジ＆ホワイト（オレンジ・ベルトン【訳注：ベルトンとは、ローンで斑があるように見える被毛パターンの一種】）、ホワイトにブラックのマーキング（ブルー・ベルトン）、トライカラー（ブルー・ベルトン＆タン）、レモン・ベルトンやレバー・ベルトンを含む、さまざまなバリエーションがある。

42.

English Springer Spaniel

イングリッシュ・スプリンガー・スパニエル

イングリッシュ・スプリンガー・スパニエル、という名前は、この犬種の鳥を素早く飛び立たせる能力、すなわち獲物を空中に「スプリング（飛び立たせる）」する能力に由来している。スパニエル種の中で最古の種類と考えられていて、クランバー・スパニエルを除くすべてのランド・スパニエル犬の祖先だともされている。かつてはコッカー種とひとまとめにされており、同腹の子として生まれてくることもあったが、19世紀後半に最終的に別の犬種として分類された。この犬は、ぶら下がった耳、優しい表情、がんじょうな体格、心地よくゆれる尾を備えた、紛れもないスパニエル種の一員である。どこをとっても完全なるスポーティング・ドッグで、活発で明るく、美しさと知性に熱意と従順な態度を兼ね備えたイングリッシュ・スプリンガー・スパニエル。しつけにもよく反応し、ゲームも大好きで、特にボールを捕ってくる遊びを楽しむ。

外見：美しく、コンパクトでがんじょうなつくりの均衡のとれた体格で、尾は断尾されている場合もある。ブリティッシュ・ランド・スパニエル種の中で脚が長めで、最もすっきりした体のつくり。

毛色：ブラックかレバーにホワイトのマーキング（またはその逆のパターン）、ブルーまたはレバー・ローン、トライカラー（ブラック＆ホワイトまたはレバー＆ホワイトにタンのマーキング）。

43.
Flat-coated Retriever
フラットコーテッド・レトリーバー

人なつっこくて楽天的なフラットコーテッド・レトリーバーは、レトリーバー犬の中では軽量の体格をしている。アイリッシュ・セター、ラブラドール、ウォーター・ドッグ、レッサー・ニューファンドランドの交配種で、泳ぎの名手や鳥獣犬としての腕前から、19世紀にはイギリスの狩猟番人たちに重宝されるようになった。多くの他の犬種と同じく、フラットコーテッド・レトリーバーも第一次・第二次世界大戦の間に劇的に減少したが、数名の献身的な愛好家たちのおかげで、現在でもこの犬種を享受できている。優しく遊ぶことが好きで、分別があり落ち着いているけれど、いつまでも子犬のような一面もある。子供たちと一緒に過ごすことも大好きで、賢い暮らし方をするので立派な番犬にもなる。外に出ると活発に動くが、家の中ではおとなしいため、ペットとして最適な犬だ。

外見：中型だが、他のレトリーバー犬よりもよりほっそりとしていて、顔の前面が角ばっていない。特徴的な被毛は濃く、ぴったりと寝るように生えていて、しっかりグルーミングすると見事な輝きを放つ。

毛色：ブラックかレバー。

44.
German Shorthaired Pointer
ジャーマン・ショートヘアード・ポインター

貴族のような雰囲気とたくましさを携えたジャーマン・ショートヘアード・ポインターは、理想的な多目的犬である。この犬種は、狩猟能力、なめらかな輪郭、上品な外見に加えて、人当たりのよさを持ち合わせている。19世紀、ドイツのハンターたちは、鼻が利き、音で獲物を指し示す能力を備えた犬を強く求めていた。水中でも陸上でも、獲物を追跡し回収してくる能力が必要とされ、その獲物は、キジ、ウズラ、ライチョウ、水鳥、アライグマ、フクロネズミからシカまで、多岐にわたった。ジャーマン・バード・ドッグとオールド・スパニッシュ・ポインター、イングリッシュ・フォックスハウンドを、地元ドイツのセント・ハウンド犬であるシュヴァイスフントと交配したのが、この犬のもともとの始祖だと考えられている。その後この交配種に、イングリッシュ・ポインターが掛け合わされ、より速くよりエネルギッシュな犬種が作出されたのだ。万能で生まれながらのハンターで、あまり多くの訓練を要さないので、たまの週末に歩きで狩りに出かけるくらいの人にとって、理想的な犬だ。友好的で理解力と意欲が高い性格で、家庭での生活に向いており、身体的にも精神的にも刺激を受けた時に最も満足感を得る。

外見：端整な顔立ちの、バランスのとれた中型犬。整った頭部、長く傾斜した肩、強靭な背中、しっかりと支えられた尾、そのすべてから、活力・持久力・スピードが見てとれる。注意を怠らず、活動的で、とても調和のとれた動きをする。筋肉質の体格は、なめらかでつやつやの被毛に覆われている。

毛色：単色のレバーか、レバーとホワイト（ティッキング、斑点、またはローン）の組み合わせなど。

Golden Retriever

ゴールデン・レトリーバー

人なつっこくて信頼のおける、温厚なゴールデン・レトリーバーは、史上最も広く受け入れられ、万能で、人気が高い犬種となった。19世紀中頃に、イングランドとスコットランドの境界地域で作出された、比較的新しい犬種である。犬種確立の基礎となったのは、その運動能力と度胸、知性で知られていたライト・カラーのツウィード・ウォーター・スパニエル。後に、アイリッシュ・セター、ブラッドハウンドに加えて、更にまたツウィード・ウォーター・スパニエルとの交配が行われた結果、今日のゴールデン・レトリーバーが誕生した。賢く、しつけも簡単で、もともとは猟犬として使われていたが、ショー・リング（家畜や犬などの品評会）でも強さを発揮することが判明した。多才で適応力も高く、盲導犬や薬物捜査犬、猟犬やコンパニオン・ドッグを含むさまざまな役割を担う場面で広く活躍している。寛大で優しく献身的な気質で、家庭犬として人気があり、計り知れない忍耐力の持ち主なので、特に子供がいる家庭に向いている。

外見：力強い中型犬で、バランスのとれた体形に、優しい表情を見せる。頭部は幅広で、耳は垂れ下がっている。長すぎない美しい脚を備えた、頑丈な体つき。耐水性のある濃いアンダー・コートと、平らでウェーブのかかったオーバー・コートで覆われている。

毛色：こっくりした、明るいゴールドのさまざまな色合い。

46.
Gordon Setter
ゴードン・セター

17世紀、もともとは猟犬としてスコットランドで繁殖されていたゴードン・セター。19世紀に第4代ゴードン公爵が熱烈な支持者となったことから、人気が上昇した。非常に優れた嗅覚と、熟練したポインティング能力、回収能力によって、ゴードン・セターは傑出した鳥猟犬となっている。他の猟犬に比べるとスピードは劣るが、陸上・水中両方での狩猟能力、鋭い知性、記憶力のよさを備えているため、ひとりの人間につくす、他に並ぶもののいない狩猟犬となる。また、現存の血統種の中で最も実直で賢いとされており、特にしつけを繰り返さなくとも、年齢とともに進歩するようだ。用心深く、好奇心旺盛で自信に満ちあふれ、おまけに怖いもの知らずのゴードンは、友好的でサービス精神が旺盛である。しつけに対する反応もよく、活動的な生活スタイルを楽しむ。加えて、従順で思慮深く快活な性格のため、頼りになる働き手にも、忠誠心の高いコンパニオン・ドッグにもなる。

外見：他のセター犬より重量があり、筋肉質でがっしりとした体のつくりをしている。立派に整った頭部に、力強く均衡のとれた胴体が、気高く知的な印象。背中は平らで、尾は短く、被毛は長くなめらかな質感である。

毛色：タンのマーキングのある、濃く輝きのあるブラックだが、見た目にはリッチ・チェスナットかマホガニーに見えることも。

47
Irish Setter
アイリッシュ・セター

おもしろくて愛情にあふれ、賢く茶目っ気たっぷりのアイリッシュ・セターは、「にぎやかで愉快な」性格だと言われることが多い。鳥猟犬として繁殖され、鷹狩り競技で使われると、たちまちその運動能力を世に知らしめた。19世紀には、地元アイルランドだけではなくイギリス諸島全域で人気となる。アイリッシュ・ウォーター・スパニエル、イングリッシュ・セター、スパニエル犬やポインター、ゴードン・セターの交配によって作出されたことが広く認められている。もともと被毛の色は、レッドとホワイトだったが、19世紀初めに選択的に繁殖されたのが、現在のアイリッシュ・セターの色として典型的な単色のレッドだ。アイリッシュ・セターは、強い狩猟本能と不屈の情熱を兼ね備えた、狩猟地での頼れるパートナーとして定評がある。極めて活動的だが、穏やかで優しい気質なので、とても楽しい家族の一員になる。

外見：貴族のようで上品なアイリッシュ・セター。体高は60cmほどで、特徴的なレッドの被毛は、つやつやとした直毛だ。頭部や脚の前面の毛は短く細いが、背中や胸部、尾や脚の裏面の毛は長い。

毛色：マホガニーか、リッチ・チェスナット・レッド。胸部・のど・あごやつま先が白くなることもある。また、顔の中心にホワイトのすじが現れることも。

48.
Irish Water Spaniel

アイリッシュ・ウォーター・スパニエル

知的で好奇心旺盛なアイリッシュ・ウォーター・スパニエルは、他のスポーティング種と同様、積極的で活気にあふれる、自発的なコンパニオン・ドッグだ。古くからの犬種で、類似したタイプの犬たちの考古学的証拠として、7〜8世紀頃のものが発見されている。12世紀後半頃には、シャノン・スパニエル、ラットテイル・スパニエル、またはウィップテイル・スパニエルとして知られていた。1800年代、アイルランドのウォーター・スパニエルが改良されたことが、現在のアイリッシュ・ウォーター・スパニエルの発端となったとも言われている。この間、ジャスティン・マッカーシーという人物によってこの犬種が改良・確立され、彼が作出した有名な「ボーツワイン」というアイリッシュ・ウォーター・スパニエルが、現存のこの犬種の始祖とされることが多い。この犬種は猟犬としてたちまち人気を集め、じょうぶで全天候型の被毛と優れた水泳能力に、計り知れないスタミナで、冷たい北海の水にもすぐにうまく適応した。頭の回転が早く、はつらつとした気質とサービス精神があるので、よく奉仕するけれど気のおけない伴侶犬となる。

外見：力強くコンパクトな、優れた体の構造を持つ鳥猟犬。その容姿からは強さと持久力がにじみ出ていて、顔の毛はなめらかだが、長くゆるやかにカールした頭頂の毛と、きつくカールした濃い被毛にネズミのような尾で、すぐに見分けがつく。

毛色：こっくりと濃いレバーで、パープルがかった色味や光沢が現れることも多い。

49.
Labrador Retriever
ラブラドール・レトリーバー

かつてはブラック・ウォーター・ドッグやセント・ジョンズ・ウォーター・ドッグとしても知られていたラブラドール・レトリーバー。カナダのニューファンドランドを起源とし、氷水の海中で、魚網を海岸まで引く仕事に使われていた、泳ぎが得意な犬の血筋を引いている。狩猟能力と水泳能力が非常に高く評価され、その後19世紀の初めにイングランドへと持ち込まれた。そこで、ラブラドールは困難に満ちた先行きに直面することになる。犬に対する重い税金と検疫法によって、絶滅しかけたのだ。結果、この犬種の輸入制限がかかり、残っていた犬たちが土着犬たちと異種交配されることになった。それによって最終的にラブラドール・レトリーバーのスタンダードが確立され、1903年にはイングリッシュ・ケネル・クラブによって単独の犬種として承認されたのである。落ち着きとサービス精神があり、賢いラブラドール・レトリーバーは、慈愛に満ちた遊び心のある家族の一員として、熱狂的に受け入れられてきた。その学習意欲の高さと従順な態度で広く知られており、盲導犬や救助犬としても称賛されている。

外見：がっしりとした中型犬で、筋骨たくましくバランスのとれた体格をしている。被毛は、短く密生していてあらゆる天候に耐えることができ、オッター・テイル（カワウソのような尾）と言われる尾が特徴的。がんじょうなあごを備えた幅広の頭部に、人なっっこい瞳が輝いている。

毛色：ソリッド・ブラックに、フォックス・レッドから明るいクリームまでを含むイエロー、さまざまな濃淡のチョコレートの色調が人気。

50.
Spinone Italiano

スピノーネ・イタリアーノ

イタリアン・スピノーネや、イタリアン・コースヘアード・ポインター、イタリアン・ポインターやイタリアン・グリフォンとしても知られている、スピノーネ・イタリアーノ。誠実で穏やかな上、がんじょうで勤勉な猟犬である。ヨーロッパの他の猟犬たちと同じように、スピノーネも現地の環境と天候に合わせて改良された。この犬の場合は、イタリア北西部の山岳地帯や湿地帯に、うっそうと茂る森林地帯がそれである。作出経緯の詳細は記録に残されていないが、コースヘアード・イタリアン・セターとホワイト・マスティフに、おそらくフレンチ・グリフォンも含む3種の交配種ではないかと考えられている。万能な鳥猟犬で、長きにわたって人間に使えてきた歴史があり、鋭い嗅覚と柔らかい噛み口で高い評価を受けてきた。疲れを見せずに働くスピノーネは、献身的にその主人の命令に応じる。また、非常に社交的で度胸もあり、愛情深いため、現在ではペットとして人気の犬種となっている。知的で独立心旺盛だけれど、のんびりとした性格で、日々の暮らしにおいて、遊び好きで献身的な仲間となってくれる。

外見：力強く筋肉質で、見事なエネルギーと強さを見せる。スクエアのがっしりとした体格で、あらゆる天候下でも理想的な、やや剛毛の厚い被毛を備えている。

毛色：ホワイトの単色か、ホワイトにオレンジまたはブラウンのマーキング、オレンジ・ローン、ブラウン・ローンがある。また、オレンジ・ローンにオレンジのマーキングが入る場合、ブラウン・ローンにブラウンのマーキングが入る場合もある。

51.
Vizsla
ビズラ

ハンガリアン・ビズラやハンガリアン・ポインターとしても知られているビズラは、中型犬で、生まれながらのハンターである。古い歴史を持つ犬種で、1000年ほど前、中央ヨーロッパを放浪し、主人であったマジャール人たちを追いかけて現在のハンガリーに住み着いたと考えられている。長い間上流階級の人々のお気に入りだったこの犬は、10世紀のエッチングや14世紀の文学作品にも記録されている。ポインターとレトリーバーの洗練された狩猟能力を兼ね備えたビズラは、なんでもこなす使役犬となった。機敏で動じず、優れた嗅覚を持ち、さえぎるもののない開けた土地や獲物の隠れる茂みで、抜群にその能力を発揮する。第一次・二次世界大戦中に絶滅の危機にさらされたが、ハンガリーから密輸出されたおかげで、穏やかで感受性が強く、恐れを知らないこの気高い犬種を現在でも引き続き享受できている。元気いっぱいで賢く、防御本能があり人なつっこいビズラ。非常に優れた猟犬であり、家庭でも狩りの場でも立派なパートナーとなってくれる。

外見：比較的細身だががんじょうな筋肉質の体格で、立派な頭部の持ち主。鋭いまなざしと、知的で隙のない表情を見せる。

毛色：単色のゴールデン・ラストのさまざまな色調。

52.
Weimaraner
ワイマラナー

端麗で運動神経のいいワイマラナーは、19世紀初め頃に確立された、比較的新しい犬種だと考えられている。スピード、優れた嗅覚、勇敢さと知性を備えた犬種を念頭において、ワイマール大公国のカール・アウグスト大公の邸宅で作出されたという。アウグスト大公は特に、当時ドイツにあり余るほど生息していたオオカミやヤマネコ、シカを追跡できる、万能な狩猟犬を求めていた。犬種が確立されると、その秘義はしっかりと守られ、貴族階級の者たちにしかこの犬の所有が許されなかったほどだ。このような独占的な歴史は、1890年代に初めて設立されたドイツのワイマラナー・クラブでも引き継がれていった。先にこのクラブの会員になったものだけが、ワイマラナーを入手できる、という仕組みである。注意深くて賢く活発なワイマラナーは、身体的・精神的刺激があるとかえってかんばるタイプ。よく知る人たちに対しては愛情を込めて友好的に接するが、自身の家族の安全が脅かされた時には、手強い防御者として活躍する。

外見：この犬種の特徴であるグレーの被毛は、「グレー・ゴースト（灰色の幽霊）」というニックネームにも反映されている。スピードと持久力を求めて繁殖された、長距離レース向けの脚を備えた中型犬だ。強靭なあごと、目を引くシェード・ブルー（ブルー・グレー）またはアンバーの瞳を持つ整った顔立ち。通常、短毛でつややかなスムース・コートだが、まれに長毛タイプが生まれることもある。

毛色：単色で、マウス・グレーからシルバー・グレーのさまざまな色合いがある。

Non-sporting
ノンスポーティング

53.
American Bulldog

アメリカン・ブルドッグ

じょうぶで運動神経がよく、自信に満ちたアメリカン・ブルドッグは、イングリッシュ・ブルドッグに比べて背が高く、より軽快で敏捷性がある。イングリッシュ・ブルドッグの流れをくんでおり、もともとのブルドッグが特にアメリカ南部で飼われていた一方で、より穏やかで現代的な犬種として、現存のアメリカン・ブルドッグが改良されてきた。イングリッシュ・ブルドッグよりも長い脚と、がっしりとした筋骨たくましい胴体を備えたこの犬種は、野生イノシシやリス、アライグマの狩りだけでなく、家畜のけん引役や監視役としても活躍したという。強さと知性と献身的愛情に定評があり、飼い主を守る時の、度胸ある勇ましい行動で知られている。思いやりのある優しい性格で、子供たちにも関心を向けて守ろうとしてくれる、誠意あふれる家庭犬だ。

外見：筋肉質でたくましいが、脚の動きはすばやく軽やか。大きくてじょうぶな四角い額と箱型のマズルが、強靭なあごを支えている。短毛はきつく密生していて、ゴワゴワとした肌触りだ。

毛色：ホワイト、パイド（ホワイトの地色に他の色の斑が入る組み合わせ）やブリンドルなど、さまざまな場合がある。

54.

Bichon Frise

ビション・フリーゼ

地中海地域に起源を持つビション（またはバービション）は、その昔船乗りたちに通貨の一種として使われており、スペイン人によってカナリア諸島のテネリフェ島に持ち込まれた（またの名をビション・テネリフェ、テネリフェ・ドッグともいう）。小さくてよくはしゃぐけれど穏やかなビションは、すばらしい旅のお供だったのだ。メイク用のパフのような容姿と愉快な振る舞いで、14世紀にはイタリア人たちに、フランスのルネサンス時代には貴族階級たちに好まれるようになる。ヘンリー3世とナポレオン3世の治世時代にその名声はピークに達したが、19世紀後半になるとその人気は衰え、オルガン奏者の見世物やサーカス団の一員といった、華やかな役回りも減っていった。1933年のフランスで、やっと公式な品種としてスタンダードが登録され、ついに「ビション・フリーゼ」という名が与えられたのだった（「フリーゼ」はフランス語で「巻き毛」を意味する）。陽気な気質で知られていて、どんな年齢層の人とも一緒にくつろげるタイプ。遊ぶことが好きで子供たちとも仲よくなる傾向があるので、よき家族の一員となる。

外見：小さくて可愛らしい見た目だが、がんじょうな体格をしている。油断のない面持ちで、好奇心たっぷりの黒々とした瞳が、遊び好きで優しい性格を映し出している。

毛色：ホワイト。バフ（藁色・鈍黄色）やクリーム、アプリコットの色調が耳のまわりや胴体にわずかに出ることもある。

55.
Boston Terrier

ボストン・テリア

ボストン・テリアは、エネルギッシュで賢く優しい性格から、愛情を込めて「米国の紳士」と呼ばれている。アメリカ原産の犬種で、ブルドッグとホワイト・イングリッシュ・テリアというイギリスの犬2種の異種交配によって作出された。1889年、ボストン地区に拠点を置く大規模な愛好家団体がアメリカン・ブル・テリア・クラブを組織し、この犬種を披露したのが始まりである。当時は、ラウンド・ヘッドやブル・テリアという名称で知られていたが、ブル・テリアとブルドッグの愛好家たちの反対を受けたため、最終的にアメリカン・ブル・テリア・クラブによってボストン・テリアという名前が授けられた。手入れや運動に手がかからず、次第にペットとしての人気が高まってきたボストン・テリア。穏やかで、特に子供たちとも仲よく楽しめる気質が評判だ。軽量だが優れた番犬にもなり、抜け目なく聡明な態度で家庭生活にもよくなじんでくれる。

外見：なめらかな被毛、短い頭部、コンパクトな胴体、短い尾を備えた、中型で均衡がとれた体格。両目の間が離れていて、まん丸の瞳と大きな立ち耳が、隙のない知的な表情をより引き立てている。

毛色：通常ブリンドル、シール、ブラックに、ホワイトのマーキングが入る。一番人気はブリンドル。

56.
Chinese Shar-pei
チャイニーズ・シャー・ペイ

見知らぬ人に対してはすぐに気を許さず眼を光らせ、家族に対しては優しく高い忠誠心を示す、チャイニーズ・シャー・ペイ。古くからの犬種で、中国広東省に起源を持つと考えられている。シャー・ペイにとてもよく似た彫像と、「しわくしゃの犬」と書かれた記述から、漢王朝時代（紀元前200年代）にこの犬種の祖先が存在していたことが証明されている。中国の政治的圧力が強まった時代、犬の禁止令にともない一時消滅の危機にひんしたが、1970年代に香港と台湾でアメリカの愛好家たちによる陳情運動が起こったことが、品種の存続につながった。しわがあり、サンド・ペーパーのように粗い手触りの被毛（「砂のような被毛」という意味の名前にも反映されている）と独特な藍色の舌を持つこの珍しい犬種は、現在はとても人気があるので、絶滅の恐れは皆無である。利口で貫禄があり魅力的なシャー・ペイは、堂々として落ち着きのある外見と、穏やかで友好的な気質で、必ず家族につくしてくれる。

外見：角ばった輪郭と、体の割に大きめの頭部を持つ中型犬。子犬の頃は、短くざらざらした毛の皮膚が体のほとんどの部分でたるんでしわになっているが、成長するとそのたるみは頭部・首・キ甲（肩甲骨間の隆起）に限られるようになる。「カバのような」マズルと高い位置にある尾も、この犬種ならではの特徴である。

毛色：単色で、ホワイト以外のすべての色。

57.
Chow Chow

チャウチャウ

見知らぬ人に対する、用心深くそっけない対応で知られるチャウチャウは、賢く自立心旺盛で防御本能のある犬種だ。2000年以上も前から存在し、中国を起源とすると考えられており、狩猟犬や牧畜犬、ソリ犬として繁殖されていた。中でもスモーキー・ブルーの色で誕生したより抜きの犬たちは、仏教寺院の犬という高い身分に昇格されていたという。チャウチャウという名は、19世紀の貿易船でのこの犬の境遇に関連している可能性が高く、「骨董品・小さな装身具」といった意味を持つピジン英語【訳注：中国語・ポルトガル語・マレー語などを混合した中国の通商英語】から発展したと考えられている。ヴィクトリア女王がこの「中国の野生犬」（ロンドン動物園で授けられた称号）に興味を示したことから、人気が高まった。現在、チャウチャウは高級なペットかつ番犬となり、主人への忠誠心と献身的愛情が称賛されている。

外見：たくましい筋肉質で、骨太でじょうぶな力強い犬種。コンパクトな胴体に、フラシ天（ビロードの一種）のようなつやの、たっぷりとしたダブル・コートでラフとスムースの2パターンがあり、尾のつけ根は高い位置にある。自信に満ちた態度で、竹馬に乗ったようなユニークな歩き方を見せる。頭部は大きく、幅広で平たいスカルに小さくて奥行きのあるマズルと、藍色の舌が特徴的。

毛色：レッド、ブラック、ブルー、フォーン、クリームの5色が基本で、混じり気がない色か単色。首まわり・尾・足のふさ毛が明るめの色調になる単色の場合もある。

58.

Dalmatian

ダルメシアン

ダルメシアンの歴史は謎に包まれているが、その名前のもととなったダルマティア【訳注：クロアチア南部アドリア海沿岸の一地方】との関連がある、というのが有力な説である。何世紀にもわたって変わらぬ姿のまま存在し、数多くの大陸で生息してきたことでも知られている。エジプト王族の墓の絵や、16世紀中頃の手紙、フィレンツェのスペイン人礼拝堂で1360年代に描かれたフレスコ画、そのすべてに斑点のある犬が描かれているのだ。これに類似した模様のある犬が、インドからヨーロッパ経由で、ジプシーたちとともに英国へやって来たという。ダルメシアンは、クロアチアとダルマティアの境界での見張り番から農場犬、狩猟犬、曲芸犬、消防犬、馬車犬、といったさまざまな役目を通して人間に仕えていた。非常に活発で、優れた持久力とスピードを備えている。同時に、堂々と落ち着きはらった、人なつっこくも紳士的な気質が、すぐにみんなをとりこにするダルメシアン。ものわかりがよく、実直で礼儀正しいので、とても献身的な仲間となる。

外見：特徴的な斑点のある被毛は、短く硬く密生しており、なめらかでつやがある。たくましく筋肉質な体格で、頭部は長めである。

毛色：ホワイトの地色に、頭から足までブラックかレバーの斑点に覆われている。

59.
English Bulldog

イングリッシュ・ブルドッグ

友好的で気立てがよく、見る者に威力と威厳の印象を与えるイングリッシュ・ブルドッグ。粘り強い性格のため、頑固に見えることもあるだろう。初めは、闘犬やブル・ベイティングのような競技に適した、計り知れない度胸を持つどう猛な犬としてイギリスで繁殖されたが、現在のブルドッグはその先祖の攻撃的な資質を何ひとつ引き継いでいない。イギリスでこれらの競技が違法となったのをきっかけに、ブリーダーたちはこの犬種の好ましい資質だけを残すことを追求した。今日では、ブルドッグは最も優秀な犬の体の見本のひとつとされていて、優しい気質と友好的なふるまいに評価も高い。親切で愛想がいいので、子供たちや初めて会う人にもうまく接することができる。

外見：体高が低くずっしりとした中型犬で、幅広の肩で、鼻先から後頭部までが短い。短い被毛はなめらかで、筋肉質なつくりの体を引き立てている。

毛色：ブリンドルか単色。レッド・ブリンドルから、ホワイトやレッド、フォーンまたはファロー（淡黄色）やブラックの単色、パイドまで、そのパターンはさまざまだ。

60.
French Bulldog

フレンチ・ブルドッグ

フレンチ・ブルドッグは、小型のイングリッシュ・ブルドッグの血統を受け継いでおり、移民が増加した19世紀中頃にフランスに持ち込まれたと考えられている。フランスに渡ってから現地のさまざまな犬種と交配され、「ブルドッグ・フランセーズ」と名付けられた。やがて、そこから2つのタイプが生まれた。ひとつが「バット・イヤー（コウモリ耳）」を持つタイプで、もうひとつが「ローズ・イヤー（バラの耳）」を持つタイプである。特徴的なコウモリ耳の方が、アメリカの愛好家の心をつかみ、この犬種を熱愛した人々による団体が世界で初めてアメリカで設立された。現在にいたるまで、その魅力的な性格によって、数多くの忠節なファン層を獲得してきたフレンチ・ブルドッグ。お行儀がよく、優しくて遊び好きな気質から、最高の家庭犬となる。また、忍耐強く冷静な気質でサイズもコンパクトなので、お年寄りのよきパートナーとしても完璧だ。

外見：コンパクトで筋肉質の、中くらいか小柄な体格。骨太で、被毛はなめらかな短毛をしており、油断のない、好奇心旺盛な表情を見せる。

毛色：人気が高いのが、フォーン、ホワイト、あるいはブリンドル。額の下部中央にすじが現れるケースは珍しい。

61.
Keeshond

キースホンド

活発で理解力の高いキースホンドは、スピッツ種のひとつであり、北極あるいは北極地方を起源に持つのではないかとされている。キースホンドはオランダでの評判が非常に高く、18世紀には政治的象徴にもなったほどだ。かつてキース・ド・ギゼラー率いる愛国党にシンボルと称されたが、オラニエ公の支配下となってからは、反勢力党となった愛国党に関連のある犬を欲しがる人々はほとんどいなくなり、人気が失われてしまう。しかし1920年代から復活の兆しを見せ、ヨーロッパ全土での人気は少しずつ高まっていった。キースホンドは賢く友好的で、優しくて人との交流も大好きなので、子供たちがはしゃいでからんできても楽しめるタイプだ。用心深く、鋭い聴覚を備えているので、優秀な番犬にもなる。

外見：端整でバランスのとれた体格の持ち主。ほぼ方形の胴体は、たっぷりとした毛に覆われ、ライオンのようなたてがみに、背中に向かってカーブしたふさふさの尾を備えている。小さくとがった耳で、用心深いキツネのような表情を見せる。

毛色：グレー、ブラック、クリームが混ざった色で、広い範囲に模様が入っている。

62.

Lhasa Apso

ラサ・アプソ

チベットの聖地ラサ周辺地帯に起源を持つ、ラサ・アプソ。地理的に過酷なこの国を原産とする、3種のノンスポーティング犬のひとつである。もともと、「よく吠える、ライオンのような見張り犬」という意味の「アプソ・セン・キュイ」と呼ばれていて、主に番犬として使われていたようだ。この役目としては違和感を感じる容姿かもしれないが、鋭い聴覚と用心深い気質で優秀な番犬となり、マスティフが屋外を警護したのに対し、ラサ・アプソは居住地内を警護した。幸運を招くとされており、伝統的に、売買ではなく贈り物として人々の手に渡ったという。そのうち世界中に広まったこの犬種は、ダライ・ラマからの贈り物としてアメリカに持ち込まれたと考えられている。人見知りする傾向があるが、自分の家では防御につくす。聡明で明るく献身的な性格で、現在ペットとしての人気も高い。

外見：コンパクトで均衡のとれた体格で、キ甲までがおよそ25cmほどの高さ。濃く厚いまっすぐの被毛と、目にかかる前髪や、立派なほおひげとあごひげが、見事に光彩を添えている。

毛色：ブラック、ホワイト、ブラウン、ゴールド、サンディ（砂色）、ハニー（はちみつ色）、ダーク・グリズル、スレート（暗い青みをおびた灰色）、スモークまたはパーティ・カラー。

63.
Lowchen

ローシェン

15世紀中頃の絵画や文学作品にも登場しているローシェンだが、その起源については明らかにされていない。当初は地中海原産と考えられていたが、現在ではドイツ原産（ローシェンという名がドイツ語で「小さなライオン」を意味する）ではないかという説が有力である。一時は流行の犬種だったが19世紀になると人気が衰え、第二次世界大戦後には「めったに見ない犬」と命名されたほどだった。しかし、その後献身的な繁殖計画によって犬種の存続が確保され、再び人気を取り戻した。警戒心と好奇心が強い「小さなライオン」は、伝統的に、体の後部を短く刈り上げ、前部はたてがみのようにたっぷりと自然に毛を残す、そのライオンの称号を反映したグルーミングをされてきた。小さくて、活発で慈愛に満ち、理解力が高く従順なので、管理がしやすいペットになる。

外見：スタイリッシュで、誇らしげな表情を浮かべるローシェン。バランスのとれたがっしりとした体格で、スカルのてっぺんとマズルは比較的短い。

毛色：すべての色、またはあらゆる色の組み合わせになりうる。

64. *Standard Poodle*

スタンダード・プードル

高貴な雰囲気をまとった上品なスタンダード・プードルは、その知的で従順な気質で知られている。3種のプードル犬の中で最も古く、ドイツ原産だと考えられているが、それに関しては、スタンダード・プードルを国民的犬と位置付けるフランス人との間で激しい論争があった。プードルという名は、よく知られた彼らの水中での回収能力に由来していて、ドイツ語の「Pudel」、「Pudelin」という、「水中でしぶきをあげる」という意味の言葉からきている。プードル特有の毛の刈り方は、もともとは泳ぎやすくするためと、冷たい水から体の重要器官を守るためにされたスタイルだった。現在、スタンダード・プードルは、人気・評判ともに高い犬種である。活発でよくはしゃぎ、自由に走ったり泳いだりすることと、人と交流することが大好きだ。

外見：堂々とした振る舞いを見せるおしゃれな犬種で、スクエアでバランスのいい体格をしている。肩の最も高い位置までが38cmを超え、伝統的なパピー・クリップ、スポーティング・クリップ、イングリッシュ・サドル・クリップ、コンチネンタル・クリップというスタイルで毛が刈られるのが一般的だ。

毛色：あらゆる色の単色。さまざまなグラデーションになることもある。

65.

Tibetan Spaniel

チベタン・スパニエル

その昔、チベット僧の「小さなライオン」犬と信じられていたチベタン・スパニエル。宗教的に崇高な価値があるとされ、チベットやその周辺の仏教国の間で贈り合うことも多かったという。このようなやり取りが、同じ種族の中でもさまざまなバリエーションが生まれることにつながっていった。例えば、中国国境沿いでは短めのマズルが主流だった一方、僧院は小さめの犬を繁殖するのが一般的だった、という具合だ。主に、幸運をもたらすコンパニオン・ドッグとみなされていたが、番犬としても名高い犬種だった。僧院の塀の高い位置に鎮座し、優れた視覚を働かせて誰か近づいてくる時には吠えて警告した。現在、チベタン・スパニエルは世界中で愛され、称賛されている。相変わらず、座って世間を見わたせるような高い所が好きなようだ。知的で協調性もあり、快活な性格がその小さなサイズと相まって、理想的な伴侶やペットとなる。

外見：人目をひくバランスのいい小型犬で、体高よりも若干体長の方が長い。頭部は小さいけれど堂々としており、被毛は長めでシルクのようである。

毛色：単色や混色のさまざまなパターンがあるが、ゴールデン・レッドが一般的だ。

66.
Tibetan Terrier

チベタン・テリア

人当たりがよく優しいチベタン・テリアは、前出のチベタン・スパニエルとラサ・アプソに続く、チベット原産のノンスポーティング種である。2000年ほども昔にさかのぼる歴史を持つ犬種で、飼い主に幸運を授けることができる貴重な贈り物と考えられていた。純血種として保たれたのは、異種との交配が災難をもたらすのではないか、と人々が恐れた結果である。ペットとしても尊重されていた上、家畜の世話や護衛にも広く役立っていた。その後1920年頃、病気の女性を救った感謝の印として、チベットに訪れていた医者に贈与されるかたちでイギリスに持ち込まれたという。サイズが「テリア」というだけで、テリア種の特徴は他に見られないが、たちまち人気の犬種となったチベタン・テリア。人好きで社交的な、いきいきとした性格に定評があり、楽しいコンパニオン・ドッグになる。知的で感覚が鋭く、見知らぬ人には用心深いが、飼い主一家に対しては偽りなく忠誠をつくす。

外見：たっぷりの毛に覆われた筋肉質の体格で、四角いつくりの中型犬。独特の足のつくり（厚くてじょうぶな肉球のある、平らで丸く大きい足）と、体を保護する厚い被毛と、目と顔の前面に多いかぶさる長い毛が、この犬種が作出された過酷な環境を物語っている。

毛色：ホワイトからブラックまで、あらゆる色の単色や組み合わせがある。

Terrier
テリア

67.
Airedale Terrier

エアデール・テリア

テリア種の中で最大のサイズを誇る、優しくて頼りになるエアデール・テリア。イギリスのヨークシャー地方で、害獣退治のため約100年前から繁殖されていたこの犬種は、ワーキング・テリア、ウォーターサイド・テリア、ビングリー・テリアといったさまざまな名で知られていたが、後にヨークシャー地方のエア渓谷にちなんだ名前がつけられた。優れた泳ぎ手で鋭い嗅覚を持った、古代種オールド・イングリッシュ・テリアやオッター・ハウンドと交配された結果、より大きくて強い、嗅覚の優れた狩猟用のテリア犬が誕生したのである。視覚・聴覚も優れていて、非常にすばしっこく、確固たる忠誠心も持ち合わせたエアデール・テリアは、ドイツとイギリスで警察犬を務めた最初の犬となった。また、怪我を負った時でも進み続ける頼もしい運び手として、戦時下でも珍重された。理解力が高くて信義にも厚く、断固服従を貫くといったそのすべての性質から、優れた番犬にも、忠実なパートナーにもなる犬である。

外見：テリア犬の中で最も大きいエアデール・テリアの平均体高は、61cmほど。じょうぶで針金のような被毛が、がっしりとした胴体を覆っている。この美しい犬を特徴づけている、ひげのある顔が印象的。

毛色：ブラックかダーク・グリズル・サドル【訳注：サドルとは、背中の中央部分に、地色よりも濃い毛が覆いかぶさったパターン。英語で「鞍」の意味】で、頭部・耳・脚はタン。

68.
Australian Terrier

オーストラリアン・テリア

人なつっこくて機敏な動きを見せる、じょうぶな小型犬のオーストラリアン・テリアは、ワーキング・テリア種の中で最も小さい犬のひとつ。そもそもは、19世紀に、オーストラリアへの開拓者たちのコンパニオン兼使役犬として改良された犬種で、齧歯動物やヘビなどを処理したり、羊や牛の世話をしたりしていた。また、オーストラリアで承認された初めてのオーストラリア原産の犬種で、1896年までに確立された犬種のスタンダードとともに、他の国々でも公式に受け入れられた。万能な使役犬先祖伝来の恩恵として、卓越した聴覚と視覚を備え、ジャンプの達人でもあり、地面を掘る名人でもある。友好的で自信にあふれ、子供たちやお年寄り、障害を持つ人たちとの親和性も高い。ドッグ・ショーや都会での生活、家庭や農場といったさまざまな場面で、その名が知られている。

外見：小さくてじょうぶな、ほどよい骨量のテリア犬。体高よりも体長が長く、立ち耳と断尾が特徴的。ざらざらした手触りのアウター・コートと、首まわりや胸部の独特な毛、柔らかでなめらかな冠毛を備えている。

毛色：ブルー＆タン、単色のサンディやレッド。

69.
Border Terrier

ボーダー・テリア

人間にとっての愛すべき伴侶であり、優れた農場犬でもある、優しく社交的で、しつけもしやすいボーダー・テリア。もともと、イングランドとスコットランドの境界近くのチェビオト丘陵で、農場で仕えるために繁殖されていた小さくてがんじょうなこの犬種は、時を経て価値の高い家庭犬となった。敏捷性があり威勢がいい上、穴に獲物を追い詰めながら、馬に遅れをとらずについていくことができるため、腕利きのハンターになる。この犬は、イングランド最北部のノーサンバーランド州で行われていた、ハウンド犬とテリア犬を組み合わせた独特の狩猟方法で活躍していた。その役割は、ボーダー・テリアという名前が採用された1870年頃に認知されるようになったようだ。人と接することが大好きで、陽気で気立てのいい性格なので、家族に連れ添うすばらしい家庭犬となる。

外見：中型で、肩幅がせまく胴体も細め。しなやかで運動神経がよく、カワウソのような特徴的な頭部を備えた、狩猟や穴に獲物を追い詰めるのに適した体つきだ。アウター・コートはかたくごわごわした全天候型で、アンダー・コートは柔らかい。

毛色：レッド、ウィートン、グリズル＆タン、ブルー＆タン、といった色のさまざまなバリエーションがある。

70.
Cairn Terrier
ケアーン・テリア

はつらつとしていて勇敢で、好奇心の強いケアーン・テリアはスコットランド高地で使役犬として作出された犬種だ。度胸と敏捷性、スピードに加え、岩だらけで荒涼としたスカイ島【訳注：スコットランド北西部 Inner Hebrides 諸島中最大の島】に生息する害獣を追いかけ回す能力が特に評価されていたという。現存のケアーン・テリアは、このような特色を残すよう慎重に繁殖され、他のテリア犬と異なるその背丈に、とりわけ重点が置かれた。人との交流を楽しみ、愛嬌があって優しい性格で、子供たちともうまくやっていく愛すべき家族の一員となる。エネルギッシュで好奇心旺盛な気質も知られていて、そのいい例が、『オズの魔法使い』に登場した最も有名なケアーン・テリアの「トト」である。

外見：均整のとれた体つきで、がっちりしておらず、脚は短い。後四半部はたくましく、前脚に重心を置いて立つ。毛むくじゃらの全天候型の被毛で、どこかキツネのようでもある。

毛色：クリームからレッド、またはグレーからブラックに近い色のバリエーション。

71.
Irish Terrier

アイリッシュ・テリア

遊び好きで性格のいいアイリッシュ・テリアは、もともと、アイルランドで農地の害獣撲滅のために、また、住宅や家族を守るために繁殖されていた犬だ。テリア犬の中でも最古の犬種のひとつで、19世紀後半のイギリスでその人気は絶頂期を迎えていた。細身で背が高くがんじょうな体格と、サービス精神に勤勉さが相まって、戦時下で理想的な使者や見張り番となった。現在でも優れた狩猟犬として知られているが、その他数多の犬種が歩んだのと同じ道をたどり、家庭犬の仲間入りを果たしている。生まれつき優しくて、見張りについた場所や人をしっかり守ろうとする。また、遊び心があり慈愛に満ちていて、加えて穏やかな性格のため、特に子供たちとの相性は抜群だ。

外見：容姿も性格も、ブリーダーたちに高く評価されているアイリッシュ・テリア。この犬種は、均整美・釣り合い・調和といったものの象徴にちがいないのだが、一方で非常に活発ですばしっこい動きも見せる。じょうぶで、がっしりとした骨格を備え、強さと持久力を発揮しやすい体のつくりである。

毛色：単色で、最も好まれる色はブライト・レッド、ゴールデン・レッド、レッド・ウィートンまたはウィートンである。胸部にホワイトが入ることも。子犬の時に生えることのある黒い毛は、成長すると消える。

72.
Kerry Blue Terrier
ケリー・ブルー・テリア

遊び好きで愛らしく、賢いケリー・ブルー・テリア。その名は、アイルランドのケリー州の山岳地帯に由来している。アイルランドの農民たちが、貴族階級の土地で音を立てずに狩りをするためにこの犬を繁殖していたと考えられている。陸上や水中で、主に小さな獲物や鳥の狩猟で活躍したが、牛や羊を追い集める仕事もしていた。最大の特徴は、強い印象を残すブルーの被毛。生まれた時の毛は黒いが、生後18ヶ月までにスレート・グレーや青みがかった色へと少しずつ変化する。この美しい毛色の特徴がイギリスの愛好家たちの心を動かし、ケリー・ブルー・テリアをショーに出場させ、お百姓の狩猟犬からおしゃれなショー・ドッグへとその地位を高めたのである。穏やかで友好的な気質と鋭い知性を兼ね備え、使役犬や狩猟犬としてだけでなく、社交的で愛情あふれるコンパニオン・ドッグにもなる万能な犬種だ。

外見：チャンピオンのような態度を見せる、誇り高き犬。グルーミングされた、背が高く力強いケリー・ブルー・テリアは、あらゆる犬種の中でも最も人目をひく犬のひとつである。テリア犬のスタイルと特性がはっきりと現れていて、筋肉質でバランスのとれた体格と、濃く柔らかウェーブのかかった被毛が特徴的。

毛色：生後18ヶ月頃まではタンかうすいブラックのさまざまな色合いだが、その後ブルーの色調となり、ブラック・ポイントが入る場合もある。

73.
Miniature Schnauzer

ミニチュア・シュナウザー

好奇心旺盛で茶目っ気があり、賢いミニチュア・シュナウザーは、ドイツ原産の犬種だ。同系統で体格が大きいスタンダード・シュナウザーと、サイズ以外の特徴は同じで、シュナウザー種の中で一番人気である。小さいサイズのスタンダード・シュナイザーとアーフェンピンシャー、プードルの選択的交配によって作出され、19世紀末に個別の犬種となった。当初は納屋のネズミ退治に使われた農場犬だったが、その明るい気質とサービス精神は、家庭での生活にも向いていた。テリアの中で最も人なつっこいことで知られ、子供たちとも喜んで接するタイプである。活発で注意深く、他のテリア犬と同様、見知らぬ人が近づいた時は吠えてしきりに合図を送る優れた番犬になる。

外見：たくましく強壮な体格のミニチュア・シュナウザーは、ほぼ正方形の胴体で、体長と肩までの高さがほぼ同じである。手触りが粗く針金のようなアウター・コートと、柔らかく密生したアンダー・コートが特徴的で、豪華なほおひげ・あごひげ・まゆ毛によって完璧な被毛となっている。

毛色：ソルト＆ペッパー（黒胡椒と塩を混ぜたような灰色）がよく見られるが、ブラック＆シルバーになることも。単色のブラックになることもあるが、それは稀なケースだ。

74.
Parson Russell Terrier

パーソン・ラッセル・テリア

19世紀のイングランド南部で、とりわけキツネ狩りのために作出されたパーソン・ラッセル・テリアは、順応性のある決然としたハンターである。疲れを見せずに獲物を追い立てることができ、怖いもの知らずで、群れをなして長距離にわたる狩りをこなす能力や、穴に入り込んでキツネを追い詰め逃げられなくする能力でも有名だ。イギリス一有名だった狩猟家で、「遊猟好きの牧師(パーソン)」としても知られていたジョン・ラッセル牧師にちなんで、その犬種名がつけられた。絶滅したオールド・イングリッシュ・ホワイト・テリアと、初期のマンチェスター犬に似たブラック＆タンのテリア犬の交配種、という説が一般的である。知的で決断力があり、運動神経もよく、とても愛情深くて友好的な性格のパーソン・ラッセル・テリア。遊ぶことが大好きで、頭脳的にも身体的にも刺激を受けている時にベストの状態となる。

外見：スピードと持久力を発揮するのに向いている体のつくりで、均衡のとれた中型犬。スムースかラフの全天候型の被毛に、コンパクトな体形、小さくしなやかな胸部、そのすべてから、優れた猟犬というかつての役割が見てとれる。

毛色：ホワイトが主流。ブラックまたはタンのマーキングがあるホワイトになったり、これらの色の組み合わせになることもあるが、通常混じり気のない色が出る。

75.
Scottish Terrier

スコティッシュ・テリア

スコティッシュ・テリアは、キツネやアナグマ狩りのために18世紀のスコットランドで作出された。スコットランド原産の5種のテリア犬の中のひとつで、当初はスコットランドの町の名前をとって「アバディーン・テリア」と呼ばれていたという。後に、その荒っぽい気質に関連付けて「リトル・ダイハード（小さな頑固者）」というあだ名もつけられている。獲物を追って穴に入りやすい小さな体だが、がんじょうな体のつくりと果断に富む態度から、たくましくて忍耐強い働き手にもなった。短い脚の犬種にしては、おどろくほど俊敏なスコティッシュ・テリア。現在では、崇められたハンターというよりも、おしゃれなコンパニオン・ドッグとなっている。威厳があり勇敢で、つねに注意を忘らない活発な犬だ。他の犬に対しては激しく対抗意識を見せるが、人間と接する時は友好的で優しい。

外見：がんじょうでがっしりとした骨格で、かたく針金のような全天候型の被毛にしっかりと覆われている。たっぷりとしたあごひげに、大きな立ち耳とまっすぐとがった尾が特徴的。

毛色：ウィートン、ブラックか、あらゆる色のブリンドル。ブラックやブリンドルに、ホワイトかシルバーの毛が被毛全体にちりばめられる場合もある。

76.
Soft-coated Wheaten Terrier
ソフト・コーテッド・ウィートン・テリア

遊ぶことが好きで、理解力が高く、優しい気立てのソフト・コーテッド・ウィートン・テリア。アイルランドに起源を持つ、3種の大型テリア犬の一種である。万能な農場犬として作出され、テリア犬の役目であった害獣の処理だけではなく、家畜の世話や家族や土地を守ることでも活躍したという。自然淘汰の過程で最も強くて勇敢な犬だけが繁殖し、結果として非常にいい体のつくりの中型犬が誕生した。落ち着きのある気質が、典型的なテリア犬の用心深さと知性と合わさった、頼りがいのある使役犬である。優雅で楽天的なウィートンは人間が大好きで、愛情を注がれるととてもよろこぶ。強い狩猟本能を持つ、賢く自信に満ちたこの犬は、すばらしいコンパニオン・ドッグになってくれる。

外見：がんじょうでスクエアの、しっかりとした体のつくりの中型犬。他のテリア種と異なる特徴的なウィートン（小麦色）の被毛は、たっぷりとしたウェーブかゆるやかなカールになっていて、柔らかくなめらかな肌触りである。

77.
West Highland White Terrier
ウェスト・ハイランド・ホワイト・テリア

赤毛のウェスト・ハイランド・ホワイト・テリアがキツネと誤って撃たれた事件が起こったのがきっかけで、「今後は見つけやすいホワイトの被毛だけが繁殖されるべきだ」という決定がなされた、という言い伝えがある。また、スコットランドのポルタロック原産で、100年以上前から存在していたとも考えられている。かつては「ローズニース・テリア」や「ポルタロック・テリア」と呼ばれていたが、20世紀初頭にウェスト・ハイランド・ホワイト・テリアという名前に変更された。狩りの場での、賢く抜け目ない誠実な狩猟スタイルに定評があるが、仕事を離れるとよくはしゃぐお人好しなので、テリア種の中では比較的人なつっこいと言われている。いつも好奇心旺盛で社交的な性格のため、人と接するのも注目されるのも大好き。折に触れて、「小さな体にスコットランドの血気がつまっている」と評されてきた犬種である。

外見：たくましく見えるが、スコティッシュ・テリアほどがっちりはしていない。均整のとれた体形で、まっすぐな背中とたくましい脚を備えている。粗くまっすぐの被毛は、背中と側面を長く残し、首と肩に向かって短くなるよう整えられることが多い。

毛色：ピュア・ホワイト。

Toy
トイ

78.
Brussels Griffon

ブリュッセル・グリフォン

知的で用心深く、繊細で自尊心が強いブリュッセル・グリフォンは、トイ・グループの中ではがっしりしたタイプの犬だ。作出についての記録はほとんど残っていないが、19世紀に馬車の御者が馬小屋のネズミを処理するために小型のテリア犬を飼っていて、その犬がアッフェンピンシャーに似た「グリフォン・デキュリ」やワイヤー・コートの厩舎犬として知られており、ジャーマン・アッフェンピンシャーやベルギーの野良犬の子孫だったという説が広く認められている。後に、パグの種族や、キング・チャールズ・スパニエル、ルビー・スパニエルと掛け合わされたとも言われている。その結果、ふたつの異なるタイプが誕生した。ひとつはスムース・コートで、もうひとつはラフ・コートでほおひげを備えていた。ブリュッセル・グリフォン特有の印象的な顔の特徴は、スパニエル種の血筋によるところが大きい。馬小屋での犬の需要が減少するのに伴い、この繊細な犬種は貴重なコンパニオン・ドッグとして家庭で受け入れられていった。ブリュッセル・グリフォンは、1997年のヒット映画『恋愛小説家』において、ジャック・ニコルソンと並んで重要な役を演じ、名を揚げたことでも知られている。

外見：ほとんど人間と言ってもいいような表情を見せるブリュッセル・グリフォン特有の顔は、短く上向きで大きく丸みがある。短い鼻と異常に大きな黒々とした瞳が、ひときわ目立っている。短くたくましいがっしりした胴体で、被毛はスムースとラフの2パターン。

毛色：リッチ・レッド、ブラック＆タン、ブラックのバリエーションを含む、さまざまな場合がある。

79.
Cavalier King Charles Spaniel
キャバリア・キング・チャールズ・スパニエル

ほれぼれするほど優しくて、遊び心あふれる知的なキャバリア・キング・チャールズ・スパニエル。かつては贅沢品であり、何世紀にもわたって貴族の家族とともにタペストリーや絵画で描かれてきた。キャバリアの熱烈なファンだった、イギリスのチャールズ王2世にちなんでこの名がつけられたが、彼の統治が終わると、この犬種も処分され絶滅寸前となってしまう。後にヴィクトリア女王がキャバリアの名誉を復活させたのだが、その時までにこの犬種は、原型から大幅に姿を変えていた。今日わたしたちが知るところのキャバリアは、王室の保護を受けていたその祖先を見本に慎重に作出され、再生された繁殖計画を経て、1940年代に単独の犬種として分類されたものである。愉快で社交的な優しい性格で、理想的なペットになるキャバリア。探検や遊ぶことも大好きだが、理解力が高くサービス精神もあるので、しつけに対する反応もいい。

外見：小さくてバランスがよく、中肉中背の胸部と肩部に、ほどよい骨量の体つき。被毛は長く、なめらかだ。

毛色：ルビー（レッド）、ブラック&タン、ブレンハイム（リッチ・チェスナットとホワイトの混色）、トライカラー（ブラック&ホワイト&タン）。

80.
Chihuahua

チワワ

かつては聖なるものとみなされていた、すこぶる元気で冒険好きな誇り高き小さな犬。アメリカ大陸で最古の犬のひとつと考えられていて、メキシコのチワワ州にちなんでその名がつけられた。現在のメキシコですでに9世紀から存在していた、トルテック族【訳注：10世紀から11世紀にわたってメキシコを支配したと言われる種族】のコンパニオン・ドッグ、テチチの血筋を受け継いでいるとされる。チョルラのピラミッドや、ユカタン半島のチェチェン・イッツアに残された肖像の中に、チワワに似た犬が発見されているのだ。チワワをより小型化するため、チャイニーズ・クレステッドと交配されたとも考えられている。現在、チワワは大人気のコンパニオン・ドッグで、注目されたがりでもあるが、同じくらい周りにも気を配る性格だ。いくぶんテリア犬のような気質で、賢いけれど少し頑固な一面も。非常に忠誠心が高く、しつけには忍耐強く応じる。

外見：小さくて均整のとれた、きゃしゃな体格。短く密生した柔らかいスムース・コートと、長く細くシルキーなロング・コートの2パターンがある。大きくまっすぐな耳の持ち主で、まんまるの目と目の間は離れている。

毛色：レッド、ホワイト、チョコレート、ブラックを含むさまざまな色のパターンがあるが、最もよく見られるのはフォーン。

81.
Chinese Crested
チャイニーズ・クレステッド

チャイニーズ・クレステッドは、人なつっこくて遊ぶことが好きな賢い犬だ。ヘアレス（無毛）とパウダー・パフのふたつのタイプがあり、商人たちによって世界中に広まったアフリカの無毛の犬の血筋を受け継いでいるとも考えられている。小さなサイズが重宝され、その結果中国人たちの手でさらに小さく改良された後、中央・南アメリカ、アジア、アフリカへと取引されたという。ヨーロッパの人々がこの犬種に心を奪われたのは19世紀頃のようで、当時の絵画や建築作品にも描かれている。地面を掘ったり這い上がったりするのが大好きで、かつては小さな害獣の捕獲で活躍していた。いつも抱っこされたくてたまらない様子で、人間に可愛がられることが大好き。子供たちとの交流も楽しむタイプで、芸を覚えるようしつけることもできる。

外見：小さくて活発な愛玩犬。ヘアレス・タイプは、頭部・足・尾にのみ毛が生えている。パウダー・パフタイプは、よりずっしりとした体つきで柔毛で完全に覆われている。

毛色：さまざまな色のパターンがあるが、最も一般的なのがホワイトからシルバーがかったホワイトの色合いである。

82.
Havanese

ハバニーズ

地中海沿岸地域原産の、古い歴史を持つハバニーズ。16世紀初頭、スペインの貿易商たちがこの小さな犬をキューバに持ち込んだと考えられている。キューバの貴族たちにとても可愛がられたハバニーズは、外からの影響を受けずに進化を遂げ、その孤立した状況下で独特の被毛の質感が生まれた。18世紀中頃までにその名が知られるようになり、ヨーロッパの上流階級層のペットとして人気を博した。ハバニーズの姿は過去150年もの間、実質変化していない。キューバ革命の際、11匹のハバニーズが米国へ渡ったのだが、その中から選ばれた少数の犬から派生したのが現在のハバニーズだという。相手をよろこばせるのが好きで穏やかな性格なので、チャーミングでとても愛される家庭犬となる。献身的で愛情深く、気立ての優しい誠実な犬だ。また、理解力も高いため、しつけにもきちんと応じる。

外見：小さくてたくましいハバニーズは、体高よりもわずかに体長の方が長い。たっぷりとした、長くなめらかでウェーブのかかった毛で覆われている。

毛色：非常に珍しいケースとしてピュア・ホワイトがあるが、通常は、ライト・フォーンからハバナ・ブラウン（赤みを帯びたタバコ色）といった、フォーンのさまざまな色調になることが多い。

83.
Maltese

マルチーズ

穏やかだけれど遊ぶことも好きなマルチーズは、極めて洗練された、かなり古い歴史を持つ犬で、それは28世紀以上も前の記録に裏付けされている。非常に美しいものとして崇拝されたマルチーズが、重要な犬として称えられていたことが、古代の文学や絵画といったさまざまな作品でも見受けられる。ギリシャには、この小さな犬に捧げられたお墓が存在するほどだ。エジプトで発見されたマルチーズの彫像のおかげで、その後も社会的に名誉ある地位を保持したマルチーズは、主に王室や貴族階級の人々に飼われていた。十字軍兵士たちによってイギリスに持ち込まれたと考えられていて、そこでもたちまち人気のコンパニオン・ドッグになったという。アメリカで初めてお披露目されたのは1877年のことだが、現在でも、ペットやひっぱりだこのショー・ドッグとして、人々に敬愛され続けている。優しく穏やかな気質でよく知られているが、かなり大胆なところもある。活発でよくはしゃぎ、誠実で優しい人たちと一緒にいることで大きなよろこびを感じるタイプだ。

外見：最大体高は25cmほどで、頭から足まで、長くシルクのような被毛で覆われている。黒々とした目のまわりは黒く縁どられていて、そのたっぷりとした白い被毛とのコントラストが美しい。

毛色：ピュア・ホワイトで、レモン色を帯びる場合や、タンの色調が耳に入る場合もある。

84.
Miniature Pinscher
ミニチュア・ピンシャー

愛好家たちの間で別名「ミニピン」とも呼ばれるミニチュア・ピンシャーは、賢くて元気な犬だ。他の犬種と同様、その歴史については激しい議論が繰り広げられているが、一番古いもので200年以上も前の記録もあるという。現在では、この記録よりもずっと昔から存在していたという説が有力だ。というのも、遺物や古い絵画作品などの絵柄が、この犬種と関連していたからである。ドイツ原産で、研究者たちはダックスフンド、イタリアン・グレーハウンド、短毛のジャーマン・ピンシャーの交配種ではないかと推定している。勇敢な番犬として有名で、「小さな体の大きな犬」と言われることも多い。遊ぶことが好きで、エネルギーにあふれ、常に注意を怠らないミニピンは、とても愛嬌のあるコンパニオン・ドッグになる。

外見：たくましい体格だが、とてもすばしっこい。キ甲までの高さは最大30cmほど。均衡がとれた体のつくりで、アスリートのような容姿をしている。被毛は、短く硬いがなめらかだ。

毛色：単色のレッドやスタッグ・レッド（赤毛に黒い毛が混じっている）、ブルー、ブラック、チョコレートがあり、ほほ・くちびる・あごの下部・のど・目の上・胸部・前脚の下部・後脚の内側・尾の付け根・飛節や足の下部に赤さび色が入る。

85.
Papillon

パピヨン

16世紀の絵画にも描かれた、上品で華やかなパピヨン。フランス語で「ちょうちょ」という意味のパピヨンという名は、その特徴的な容姿が反映されたものだ。顔の中央から鼻のあたりにかけて入っている、細長く整った白い部分が、直立した大きな耳を引き立てており、より一層「ちょうちょ」の印象を強めている。犬種名とその歴史はフランスの恩恵を受けているが、パピヨンに心を奪われ、その人気を高めたのはスペイン人とイタリア人である。賢く従順で、反応もよいのでしつけもしやすく、芸を覚えることもできる。人との交流を楽しみ、精神的刺激も糧にするタイプだ。

外見：優雅さと気品の見本のようなパピヨンは、人を惹きつける魅力を放つ頭部と、しっかりとした骨格の持ち主。たれ耳のタイプはヨーロッパ全土では「ファーレン（フランス語で蛾という意味）」として知られている。どちらのタイプも、意外にたくましい体が、ウェーブ状で、長くたっぷりとしたなめらかな毛に覆われている。

毛色：ホワイトに、レバー以外のさまざまな色の模様が入る。

86.
Pekingese

ペキニーズ

ペキニーズに関する、こんな言い伝えがある。1匹のライオンが、動物たちの守護聖人に、ライオンの度量の大きい心と特徴を保ったまま、体を小さくしてほしいと懇願した。そのおかげで、そのライオンは最終的に、心から愛する相手であるマーモセット（キヌザル）と結婚することができたという。この不思議な組み合わせから生まれた子孫たちが、Fu Lin（獅子犬〈ライオン・ドッグ〉）であり、現在ペキニーズと呼ばれている犬種と言われているのだ。中国の皇族たちに飼われ、皇室ではたっぷりとした袖に入れられて運ばれたことから、その様子をストレートに表して「袖犬」と呼ばれることもあった。その歴史は2000年以上も前から始まっている、という説もある。しかし、西欧の人々がこの犬種を知ったのは、1860年にイギリスが皇居を襲撃した際に5匹のペキニーズが発見された（この5匹以外のペキニーズは殺すよう命令が下ったので敵の手に渡らなかった）後のことだった。この5匹が、現存のペキニーズの祖先だと考えられている。豪奢に崇拝されてきた長い歴史からか、少し強情で頑固になることもあるペキニーズ。同時に優しく義理堅くもあり、その性格が見知らぬ人に対しての警戒心と相まって、立派な番犬になる。

外見：小さくて均衡がとれた体格のペキニーズは、ライオンのような威厳と素養を絵に描いたようである。長くて粗い厚い被毛で、たてがみもある。

毛色：レバーとアルビノ【訳注：色素が著しく欠けた動植物のことを指す。白変種】以外の、さまざまな色や模様のパターン。

87.
Pomeranian

ポメラニアン

ポメラニアンは、活気に満ちた犬で、その陽気な性格と小ぶりな体格でたくさんの人々を大いに魅了している。スピッツ系の、アイスランドのソリ犬の血筋を引いていると考えられていて、プロイセンのポメラニア地方で小さいサイズに改良されたという説もある。19世紀後半、ヴィクトリア女王がこの犬に一目惚れし、自身の犬舎までをも設立した。彼女のポメラニアンに対する情熱は、臨終時ポメラニアンを自身の横に寝かせていた、という叙述にも見受けられる。ヴィクトリア女王が可愛がったことで上昇したポメラニアンの人気は、今なお衰えていない。賢くて好奇心が強く、それが目立ちたがり屋の性格と合わさって、非常に楽しいパートナーにも、腕のいいショー・ドッグにもなる。

外見：コンパクトで背中が短いが、とてもじょうぶな体のつくり。粗い質感の、たっぷりとした毛に覆われていて、羽毛のようにふさふさとした尾が高く平らな位置についている。その表情は、知的で用心深い。

毛色：最も一般的なのは、オレンジ、ブラック、またはクリームからホワイトにかけての色。

88.
Pug

パグ

かなり古い犬種のパグは、紀元前400年もの昔から存在する純血種と言われている。表情がパグと呼ばれていたマーモセットに似ていることから、その名がつけられたのではないかと考えられており、幸運な歴史をたどってきた犬だ。初めは、チベットの仏教僧たちの伴侶犬として、後にヨーロッパやアジアのいたるところで、さまざまな宮廷・王室でペットとして可愛がられてきた。1572年、オランダのオラニエ公ウィレム1世（1533～1594）がパグに命を助けられたことがあり、後にウィレム3世がウィリアム3世としてイングランドの王位につく際にパグを伴ったと言われている。アクセサリー感覚で流行したパグの人気は、1860年にイギリスが中国を襲撃すると再過熱した。その際、ペキニーズのように、パグもまた中国からイギリスへと持ち込まれたのである。よく「小さな体に個性がつまった犬」と評される、パグの社交的で優しい性格は、場を和ませてくれるので家族みんなのお気に入りのペットになる。気立てがよく、遊び好きなことで知られていて、子供たちとの親和性も非常に高い。

外見：スクエアの胴体にたくましい脚、そして短くてつややかな被毛の持ち主。きつく巻かれた尾が、深いしわの入ったくしゃっとした特徴的な顔との完璧なバランスを見せる。瞳は大きく、輝いている。

毛色：シルバー、アプリコット、フォーン、ブラック。

89.
Shih Tzu
シー・ズー

貴族のような雰囲気で、物怖じしないシー・ズー（獅子という意味）は、最小サイズのチベットの聖なる犬の血筋を受け継いでいる。北京の紫禁城【訳注：北京にある明清時代の宮城。現在は故宮博物院がある】で繁殖されていたらしく、紀元前624年という古い時代の絵画などで描かれていて、当時シー・ズーのつがいが中国皇室へ贈られた、という言い伝えもある。明朝時代（1368〜1644）は人々に愛されたペットだったそうだが、共産革命以降には絶滅の危機に追いやられてしまう。その時に生き残った犬たちが、恐らく現存のシー・ズー犬と直系であろう。誇らしげで自信に満ちた身のこなしが、かつての皇族たちとの結びつきを彷彿とさせる。元気があって優しい性格で、楽しい仲間として愛すべきペットになる犬だ。

外見：まさに、どこから見ても貴族そのもののシー・ズーは、尾が高い位置にあり、背中側に曲がっている。「菊犬」と呼ばれることがあるのは、鼻の上部の毛が上向きに生えているからである。長く濃い被毛が、小さいけれどたくましい体を覆っている。

毛色：あらゆる色になるが、額のブレーズとホワイトの尾先は非常に珍しく貴重とされる。

90.
Toy Poodle

トイ・プードル

スタンダード、ミニチュア、トイ、の3つのプードルのバリエーションは、実際は、サイズに違いがあるだけで、ひとつの犬種として同じ基準が適用されている。この3パターンのうち、トイ・プードルが最も賢いと言われており、その秀でた学習能力で有名だ。スタンダード・プードルと同じく、泳ぎも上手い。ドイツ原産だがフランスで最も人気を博し、ルイ16世とアン女王の統治時代に王室のお気に入りとなった際、その名声がピークに達した。しかし、本当の意味でこの犬種が作出されたのは20世紀に入ってからで、トイ・プードルという犬種としてしっかりと確立され、個別の地位が公式に認められたのは1950年代のことだった。サイズが小さく愛情あふれる性格のため、ペットとしての人気も高く、献身的で優しい、愛すべきコンパニオン・ドッグになる。

外見：まさに、大きめサイズのスタンダード・プードルのレプリカと言えるトイ・プードル。スクエアのバランスのいい体形で、堂々とした態度を見せる。スタンダード・プードルが、肩の最も高い場所が38cmより高くなるのに対し、ミニチュア・プードルは25cmを超えるものから38cm、トイ・プードルが最高25cmである。

毛色：単色だが、同じ色でグラデーションになる部分が出ることもある。

91.
Yorkshire Terrier

ヨークシャー・テリア

ヴィクトリア王朝時代後半、女性たちの間でアクセサリー感覚で所有する犬として流行したヨークシャー・テリアだが、もともとは、織物工場で機織りの職を探しにヨークシャー地方にやって来た、労働階級のスコットランド人たちによって作出された犬種である。その血筋は、現在では絶滅したウォーターサイド・テリアと関係があったとされている。加えて、ブラック・アンド・タン・イングリッシュ・テリア、ペイズリー・テリア、クライズデール・テリアもこの犬種と関係があるとも言われている。かつてのヨークシャー・テリアは現在よりも大きな体格をしており、もともとは「ブロークン・ヘアード・スコッチ・テリア」として知られていた。選択的交配によって小型化され、ウェストモーランド・ショーで「もはやスコッチ・テリアではなく、彼らがヨークシャーでよりよく改良されたのだから、ヨークシャーと呼ばれるべきだ」と評された後の1870年、改名される運びとなった。堂々とした振る舞いと贅沢な被毛のおかげで、手をかけてグルーミングすると絵に描いたように完璧なショー・ドッグになる。気質はテリア犬そのもので、はつらつとしていて愛嬌がある。既知の人たちに対しては優しく、子供たちとはしゃぎ転げて遊ぶのも大好きだ。

外見：ヨークシャー・テリアの特徴である長い被毛は、完全にまっすぐで体の左右に均等に垂れていて、分け目は鼻の先から尾の先までのびている。コンパクトで均衡のとれた体格で、自信に満ちた態度を見せる。

毛色：ピュア・ダーク・スチール・ブルー（シルバー・ブルーではない）で、胸部の毛色は根元が濃く先端に向かって明るくなっているリッチ・タン。

Miscellaneous
その他の種類

92.
Cavoodle

キャブードル

オーストラリア原産のキャブードル【訳注：日本ではキャバプーとも呼ばれる】は、純血のミニチュアまたはトイ・プードルとキャバリア・キング・チャールズ・スパニエルを掛け合わせて誕生した、スプードル（コッカプー）の小型版だ。慈愛に満ちた優しいキャバリア・キング・チャールズ・スパニエルの性格が、極めて知的で忠誠心の高いプードルの素質を見事に引き立てている。コンパニオン・ドッグとして作出され、キャバリアの社交的でのんびりとした気質とプードルのしつけやすさが相まって、家庭生活にもとてもうまくなじんでくれる。この交配のおかげで、より健康的に進化したようで、それぞれの親犬たちが本来持っていた遺伝子的な問題が大幅に減少された。手入れがしやすく、とてもおおらかで子供たちに対しても優しいキャブードル。現在、人気が高まっている犬種である。

外見：小さくてバランスのとれた体格で、ほどよい骨量。プードルのような被毛になる場合と、柔らかくウェーブがかったキャバリアのような被毛になる場合の2パターンがある。

毛色：ホワイト、キャラメル、アプリコット、ブラック＆ホワイト、ブラック＆タン。

93.

Dogue de Bordeaux

ドーグ・ド・ボルドー

ドーグ・ド・ボルドーの正当な作出の経緯については諸説あり、チベタン・マスティフの子孫だという者もいれば、ひょっとしたらナポリタン・マスティフと同系ではないかという者もいる。また、ブルマスティフやブルドッグも、ドーグの歴史の中で重要な位置を占めているという説も多くの支持を得ている。いずれにせよ、誰もが合意している点は、ドーグがフランスの古くからの犬種、ということだ。警備犬や、猟犬、闘犬として活躍し、牛・クマ・ジャガーたちに噛みついたり、イノシシを捕まえたり、牛を世話して家を守るといった訓練がなされた。これまでに2度、絶滅の危機に瀕したこともある。1度目は、フランス革命の際、裕福な飼い主たちと並んで処刑された時。2度目は、ドーグが主人に対して徹底的な忠誠心を示したことから、アドルフ・ヒトラーが彼らの処分を命じた時。今日では、子供たちに対しても非常に優しい、誠実な家族の一員とされてる。見知らぬ人を警戒するので、番犬や護衛犬として抜きん出ている。

外見：じょうぶで運動神経のいい、力強いドーグ・ド・ボルドー。筋肉質で、どちらかというと体高が低くずんぐりとして見えるが、堂々たる雰囲気を放っている。被毛は細く短く、柔らかい手触りだ。

毛色：マホガニー・フォーンからライト・フォーンにかけてのフォーンの色調で、マスク（目のまわり）はレッドかブラウン、ブラックになる。

94
Goldendoodle
ゴールデンドゥードル

愛情たっぷりで誠実なゴールデンドゥードルは、1990年代に北アメリカで誕生したと考えられている。ゴールデン・レトリーバーとプードルの混血、ということからついた名前がゴールデンドゥードルで、ますます人気を博しているキャブードルの大型版として繁殖された。親となった犬種それぞれから受け継ぎ、合わさった素質に対する評価が高い。優しくて遊ぶことが好きな性格に加えて、毛が抜け落ちにくいため、完璧なペットになると同時に、アレルギーに悩む人たちにとっての伴侶としても理想的である。頭の回転が早くてしつけもしやすく、ゴールデン・レトリーバーの回収本能を保持していることが多い。社交的で落ち着いており、世話を引き受けた対象への献身的愛情や、子供たちを溺愛し思いやりを持って接することで知られている。

外見：とても多くのバリエーションがあり、それは親犬の遺伝子群によるところが大きい。それぞれの個体の違いは、1匹の犬から一緒に生まれてくる子犬たちの間でも生じることがある。通常は、スタンダードまたはミニチュア・プードルのどちらと異種交配されたかどうかによって、スタンダードかミニかに分類される。被毛は、巻き毛、ウェーブ、ストレートのいずれかになる。

毛色：ホワイト、ブロンド、タン、チョコレート、レッド、ブラック、シルバー、パーティ・カラー、ファントム（ベースの色と明確な第2色との組み合わせ）、または混色。

95.
Japanese Spitz

日本スピッツ

体は小さいが、勇気と活力にあふれる日本スピッツ。この犬種の歴史についてはさまざまな説が飛び交っているが、モンゴルの遊牧民たちの伴侶犬だったサモエドのミニチュア版、と考えられている。アメリカン・エスキモー・ドッグと関連があるのではという意見もあるが、一般的には、ヨーロッパ大陸を横断してアジアへ渡り、日本に住み着いたとも言われている。遊び心たっぷりで優しく従順なこの犬は、もともとは家庭のコンパニオン・ドッグとして日本人の手で作出されたのが始まりだ。他のペットと一緒でもご機嫌で、特に子供たちとのじゃれ合いも楽しむタイプ。用心深く知性的でもあり、自身の家族を守ろうとする態度は、見知らぬ人が近づいた時に吠えて警告する傾向が強い点にも現れていて、そのため勇敢な番犬としても評価が高い。

外見：幅広で深い胸部が特徴的な小型犬で、堂々としていて強そうに見える。鋭くとがったマズルと、まっすぐそびえる三角の耳、背中にかかるふさふさの尾の持ち主。まっすぐのアウター・コートと、短く濃くて柔らかなたっぷりとしたアンダー・コートで、体の大部分が覆われている。

毛色：ピュア・ホワイト。

96.
Kangal Dog

カンガール・ドッグ

見るからに力強いカンガール・ドッグは、トルコ中央部のシワス県のカンガール郡で誕生した。アッシリアの絵画で描かれた古いマスティフ型の犬と関係があり、17世紀からトルコ皇帝によって繁殖されていたのではないかと考えられている。後に、オオカミやクマ、ジャッカルといった数多の捕食動物たちから羊の群れを守るため、村人たちによって繁殖されるようになった。計り知れないスピードに、強靭さと度胸が称賛されたこの犬種は、当時から今日に至るまで、その姿はほとんど変化していない。トルコの国民的な犬とされ、切手に登場したり、行政や国家の機関によって育てられたりもしている。恐ろしく大きな体のおかげであらゆる脅威を追い払うことができるが、決して対立的ではなく、むしろとても優しくて思いやりのある犬だ。その防御本能で、主人に対してとても忠実で敏感に反応する。特に、面倒をみる子供たちに対しては忍耐強く接し、彼らを守ろうとしてくれる。

外見：大きく力強く骨太で、どっしりとした頭部と短く密生した被毛の持ち主。尾は通常カールしている。

毛色：ライト・ダン（明るい灰褐色）からペール、にぶいゴールドからスチール・グレーの単色で、胸部や足、あごにホワイトの模様が入ることもある。目のまわりはブラック。

97.
Labradoodle
ラブラドゥードル

理解力が高く陽気なラブラドゥードルは、アレルギーを抱えながらも盲導犬が必要な人からの問い合わせに応じて、1970年代にオーストラリアで作出された犬だ。その犬種名からも検討がつくように、ラブラドールとプードルの交配種である。ラブラドールが選ばれたのは、穏やかな振る舞いと知力の高さで盲導犬や救助犬として実績を積んできたからだ。一方、プードルは、同じくとても賢かったことに加え、抜け落ちにくい毛の性質から選ばれることとなった。ラブラドゥードルはまだまだ新しい犬種だが、すでに多くの人々をとりこにしている。毛が抜け落ちにくいので、アレルギー患者にとっては理想的な上、その知性と多才さに社交性が加わって、補助やセラピーの仕事、危険を察知することやガイドや付き添い、といった務めを完璧にこなすことができる。万能でしつけやすく、友好的で遊び好きの性格で、ペットとしての需要が非常に高い。

外見：筋骨隆々の中型犬で、被毛はなだらかに流れるようなウェーブがかかっている場合と、巻き毛の場合がある。自由に振る舞っていい時はエネルギッシュかつ上品だが、制御されている時はおとなしくて物わかりがいい。

毛色：シルバー、クリーム、チョコレートから、レッドの混色まで、さまざまな色がある。

98.
Leonberger
レオンベルガー

レオンベルガーの歴史は興味をそそるものがあり、実際のところマーケティング・ツールとして繁殖されたのが始まりである。19世紀、ドイツのレオンベルク市の議員であったハインリッヒ・エスィヒ氏が、市の紋章に描かれたライオンに似た犬の繁殖に取りかかった。ランドシーアー・ニューファンドランドと、セント・バーナード、ピレネー・マウンテン・ドッグを掛け合わせた後に、犬種が判明されていない交配種とも掛け合わされている。エスィヒ氏はレオンベルガーを市の宣伝に利用し、王室の人々——ウェールズ王子やイタリアのウンベルト王、ロシアのツァー皇帝、オーストリアのエリザベス皇后——に寄贈したので、その全員がレオンベルガーを飼うことになったのだ。1889年、エスィヒ氏の死後に初めてレオンベルガー・クラブが設立され、1895年までにスタンダードも確立された。レオンベルガーがほとんど姿を消した第二次世界対戦を経て、繁殖計画が刷新された際に、そのスタンダードも改訂されている。理解力の高さと相手をよろこばせようとする性格がとても評判で、ヘリコプターから飛び降りるといった命令にも応じられるほど、高度な訓練をすることができる。忍耐強くて優しい犬種で、子供たちとの相性も抜群のため、よく「ナニー・ドッグ（ベビーシッター犬）」とも呼ばれる。

外見：力強くて筋肉質なレオンベルガーは、体高よりも体長の方が少し長く、深い胸部と、水かきのある珍しい足を備えている。自信に満ちた雰囲気で、力強くしっかりとした足取りと温かい表情を見せる。

毛色：イエロー、サンディ、レッドから赤みを帯びたブラウンで、ブラックのマスクになったり、ブラックのマーキングが入ったりすることが多い。

99.
Pyrenean Shepherd

ピレネー・シェパード

古くからの犬種で、ピレネーに生息していたクマやキツネたちから進化したのではという話や、もともとはピレネー山脈のクロマニヨン人たちの牧畜犬・狩猟犬だった、という話もある。また、家畜追いやコンパニオン・ドッグとして使われていた犬についての話がピレネー山脈では広く知られていて、それは中世の頃までさかのぼるという。その地域には、ともに働き活躍していた2種類の農場犬がいた。見張り番のグレート・ピレネーと、家畜の群れを移動させるピレネー・シェパードである。自分より大きな体格の見張り番の犬とともに働きつつも、ピレネー・シェパードはその小さなサイズを保持できたため、より速く機敏に動けるようになった。第一次世界大戦中、多くのピレネー・シェパードが運び屋、捜索犬、救助犬として命を捧げた結果、その知性とスピード、度胸が広く知られることとなる。働き者で、牧草地で家畜を追うのが大好きだ。極めて忠誠心が高く繊細でもあり、家族に対して愛情深く、みんなを守ろうとしてくれる。

外見：筋肉が発達したアスリートのようなピレネー・シェパード。骨量は軽めで引き締まっており、横長の長方形のような体形をしている。エネルギーたっぷりで、いつでも働く準備は万端。活力あふれる動きが、特徴的な歩き方につながっている。

毛色：フォーン&グレーのさまざまな色合い、多様なトーンのマール、ブリンドル、ブラックがある。

100.
Spoodle
スプードル

ハイブリッド種のスプードル（特にアメリカではコッカプーとしても知られている）は、非公式なかたちではあるが半世紀近くにわたって繁殖されてきた犬種で、現代のデザイナー・ドッグ【訳注：純血種を交配して人工的に作った犬種】の中では比較的古株である。純血のコッカー・スパニエルとプードルの交配種で、プードルの高い知力と抜け落ちにくい毛に、スパニエルのたくましい体格と優しく忍耐強い性格が組み合わされた結果、抜群に社交的で、誰に対しても優しい犬が誕生した。サービス精神があり頭の回転もはやいので、しつけに対してもよく反応する。人間との親和性が高く寛大な性格で、特に子供たちとの相性がいい。

外見：四角くバランスのいい体格で、抜群のスピードと俊敏性に、スタミナを兼ね備えている。親犬によって、体高はトイ・タイプからミニチュア、スタンダードに及ぶが、どのサイズでも頭部は大きく丸みを帯びていて、用心深い知的なまなざしを放つ目と目の間隔はあいている。

毛色：あらゆる色の単色やパーティ・カラー、ファントム、セーブル、ブリンドル、ローンがある。

101.
Hybrid Dalmatian & Boxer Cross

雑種　（ダルメシアンとボクサー）

本書の101匹目の犬、キズィーは、わたしが飼っている犬だ。純血種というよりも雑種犬だが、彼女以上にかけがえのない犬は存在しない。

わたしの犬遍歴は、かつて実家で飼っていたアーチーというおバカなイングリッシュ・スプリンガー・スパニエルに始まった。犬を飼うのが初めてだったので、しつけについて全くわかっていなかったわたしたち。とてもお行儀が悪かったけれど、家族はみんなアーチーのことが大好きだった。子供の頃、近所には他にも犬がいたのだが、優しくて魅力的なニューファンドランド種への愛に火をつけるきっかけとなったのは、この犬の方だった。独り立ちしてすぐに、わたしは自分でニューファンドランドを購入した。それが生涯の恋人、ヘンリーだった。ヘンリーはわたしと一緒にどこへでも出かけた。ほとんどの撮影にも同行し、愚痴ひとつこぼさずに主役を演じてくれたことも何度かある。ヘンリーは、自分自身と作品にとって、多大なインスピレーションの源だったのだ。ヘンリーを失ったことで、わたしの人生に底知れない穴が空いてしまっていた。

まだ他の犬を飼う気にはなれなかった、2年半ほど前のこと。ある友人が、「新しい家が必要な犬を知ってるんだけど、どう？」という電話をくれた。それは不意だったけれどいい機会だと思い、わたしは詳しいことを聞くまでもなく、申し出を受ける返事をしていた。今となっては、それは運命だったのだと思う。事実、キズィーはわたしにとって申し分のないパートナーとなっている。彼女は農場生まれだが、都会での生活にも見事に適応した。と言っても、わたしたちはよく、一緒に都会から脱出し田舎へ出歩いているのだけど。わたしが乗馬をしている間にウサギを追いかけるのが、キズィーのお気に入りの遊びのひとつだ。彼女は、写真撮影も上手にこなす。すごく落ち着いた性格で、子犬や子猫、赤ちゃんたちに対してとても優しいキズィー！　わたしのかわいい分身である。

レイチェル・ヘイル・マッケナ

Index

アイリッシュ・ウォーター・スパニエル............107
アイリッシュ・ウルフハウンド............24
アイリッシュ・セター............104
アイリッシュ・テリア............157
アフガン・ハウンド............7
アメリカン・コッカー・スパニエル............83
アメリカン・ブルドッグ............118
アラスカン・マラミュート............58
アルサシアン（ジャーマン・シェパード・ドッグ参照）............44
イタリアン・スピノーネ（スピノーネ・イタリアーノ参照）............110
イングリッシュ・コッカー・スパニエル............90
イングリッシュ・スプリンガー・スパニエル............95
イングリッシュ・セター............92
イングリッシュ・ブルドッグ............130
ウィペット............31
ウェスト・ハイランド・ホワイト・テリア............169
ウェルシュ・コーギー・ペンブローク............48
エアデール・テリア............149
オーストラリアン・キャトル・ドッグ............34
オーストラリアン・シェパード............37
オーストラリアン・テリア............150
オールド・イングリッシュ・シープドッグ............47
カーリーコーテッド・レトリーバー............89
カンガール・ドッグ............210
キースホンド............134
キャバリア・キング・チャールズ・スパニエル............175
キャプードル............202
グレート・デーン............68
グレーハウンド............20
ケリー・ブルー・テリア............158
ケアーン・テリア............154
ゴードン・セター............103
ゴールデン・レトリーバー............100
ゴールデンドゥードル............206
コッカプー（スプードル参照）............218
雑種（ダルメシアンとボクサー）............221
サモエド............76
サルーキ............28
シー・ズー............194
シェットランド・シープドッグ............55
シベリアン・ハスキー............78
ジャーマン・シェパード・ドッグ............44
ジャーマン・ショートヘアード・ポインター............98
スコティッシュ・テリア............165
スタンダード・プードル............141
スピノーネ・イタリアーノ............110
スプードル............218
セント・バーナード............75
ソフト・コーテッド・ウィートン・テリア............166
ダックスフンド............19
ダルメシアン............129
チェサピーク・ベイ・レトリーバー............87

チベタン・スパニエル............142
チベタン・テリア............144
チャイニーズ・クレステッド............178
チャイニーズ・シャー・ペイ............125
チャウチャウ............126
チワワ............176
トイ・プードル............197
ドーグ・ド・ボルドー............205
ドーベルマン・ピンシャー............67
ナポリタン・マスティフ............71
ニューファンドランド............72
日本スピッツ............209
パーソン・ラッセル・テリア............162
バーニーズ・マウンテン・ドッグ............61
パグ............193
バセット・ハウンド............11
バセンジー............8
ハバニーズ............181
パピヨン............186
ハリアー・ハウンド............23
ハンガリアン・ビズラ（ビズラ参照）............113
ビアデッド・コリー............38
ビーグル............12
ビション・フリーゼ............121
ビズラ............113
ピレネー・シェパード............217
プーリー............51
フラットコーテッド・レトリーバー............96
ブラッドハウンド............15
ブリアード............42
ブリタニー............84
ブリュッセル・グリフォン............172
ブルマスティフ............65
フレンチ・ブルドッグ............133
ペキニーズ............189
ボーダー・コリー............41
ボーダー・テリア............153
ボクサー............62
ボストン・テリア............122
ポメラニアン............190
ボルゾイ............16
マルチーズ............182
ミニチュア・シュナウザー............161
ミニチュア・ピンシャー............185
ヨークシャー・テリア............198
ラサ・アプソ............137
ラフ・コリー............52
ラブラドゥードル............213
ラブラドール・レトリーバー............108
レオンベルガー............214
ローシェン............138
ローデシアン・リッジバック............27
ワイマラナー............114

The following images are copyright © 2008 Rachael Hale Trust:
Back cover and pages 59 (Alaskan Malamute), 82 (American Cocker Spaniel), 36 (Australian Shepherd), 152 (Border Terrier), 42 (Briard), 85 (Brittany), 203 (Cavoodle), 86 (Chesapeake Bay Retriever), 177 (Chihuahua), 127 (Chow Chow), 220 (Dalmatian Boxer Cross), 204 (Dogue de Bordeaux), 97 (Flat-coated Retriever), 200/207/223 (Goldendoodle), 101 (Golden Retriever), 180 (Havanese), 184 (Miniature Pinscher), pp 26 (Rhodesian Ridgeback),164 (Scottish Terrier), 54 (Shetland Sheepdog), 195 (Shih Tzu), 79 (Siberian Husky), 167 (Soft-coated Wheaten Terrier), 145 (Tibetan Terrier), 30 (Whippet).

All other images, including front and back cover images, copyright © 2008 Dissero Brands Limited, New Zealand. All worldwide rights reserved. www.rachaelhale.com

Front cover and pages 6 (Afghan Hound), 148 (Airedale Terrier), 119 (American Bulldog), 35 (Australian Cattle Dog), 151 (Australian Terrier), 9 (Basenji), 10 (Basset Hound), 13 (Beagle), 39 (Bearded Collie), 60 (Bernese Mountain Dog), 120 (Bichon Frise), 4/14 (Bloodhound), 40 (Border Collie), 17 (Borzoi), 123 (Boston Terrier), 63 (Boxer), 173 (Brussels Griffon), 64 (Bullmastiff), 155 (Cairn Terrier), 174 (Cavalier King Charles Spaniel), 179 (Chinese Crested), 124 (Chinese Shar-pei), 88 (Curly-coated Retriever), 18 (Dachshund), 116/128 (Dalmatian), 66 (Doberman Pinscher), 131 (English Bulldog), 91 (English Cocker Spaniel), 80/93 (English Setter), 94 (English Springer Spaniel), 132 (French Bulldog), 45 (German Shepherd Dog), 99 (German Shorthaired Pointer), 102 (Gordon Setter), 69 (Great Dane), 21 (Greyhound), 22 (Harrier Hound), 105 (Irish Setter), 156 (Irish Terrier), 106 (Irish Water Spaniel), 25 (Irish Wolfhound), 208 (Japanese Spitz), 211 (Kangal Dog), 135 (Keeshond),159 (Kerry Blue Terrier), 212 (Labradoodle), 109 (Labrador Retriever), 215 (Leonberger), 136 (Lhasa Apso), 139 (Lowchen), 183 (Maltese),160 (Miniature Schnauzer), 70 (Neapolitan Mastiff), 56/73 (Newfoundland), 46 (Old English Sheepdog), 187 (Papillon), 163 (Parson Russell Terrier), 188 (Pekingese), 49 (Pembroke Welsh Corgi), 191 (Pomeranian), 192 (Pug), 32/50 (Puli), 216 (Pyrenean Shepherd), 53 (Rough Collie), 74 (Saint Bernard), 29 (Saluki), 77 (Samoyed), 111 (Spinone Italiano), 219 (Spoodle), 140 (Standard Poodle), 143 (Tibetan Spaniel), 170/196 (Toy Poodle), 112 (Vizsla), 115 (Weimaraner), 146/168 (West Highland White Terrier), 199 (Yorkshire Terrier).

参考図書

『新犬種大図鑑』2002年4月刊・ペットライフ社刊／著者：ブルース・フォーグル、監修：福山 英也
『最新犬種スタンダード図鑑』2003年4月・学習研究社刊／監修：芝藪 豊作、写真：中島 真理
『ブルドッグ―その意外な歴史―』2011年7月・インデックス出版刊／著者：河村玲奈、河村善也
『まるごとわかる 犬種大図鑑』2014年7月・学研パブリッシング刊／監修：若山正之
『原産国に受け継がれた420犬種の姿形　最新 世界の犬種大図鑑』2015年2月・誠文堂新光社刊／著者：藤田りか子、制作協力：リネー・ヴィレス
『ビジュアル犬種百科図鑑』2016年2月・緑書房刊／監修：神里 洋
『世界で一番美しい犬の図鑑』2016年3月・エクスナレッジ刊／著者：タムシン・ピッケラル、写真：アストリッド・ハリソン、翻訳：岩井木綿子
『オラニエ公ウィレム　- オランダ独立の父 -』2008年3月・文理閣刊／著者：C. ヴェロニカ・ウェッジウッド、翻訳：瀬原義生
『犬の歴史と発達　イヌはどこから来たか』1984年12月・誠文堂新光社刊／著者：大野淳一

本書の情報は原則すべて原書に基づいており、紹介している犬種の歴史的・文化的背景については諸説ある場合もある。また、スタンダード（犬種標準）や各犬種の情報については、犬種登録団体や、犬種ごとの愛犬家団体によって異なる場合もある。

Dogs: 101 Adorable Breeds, the original English edition, published by PQ Blackwell Limited.

Text and concept copyright © 2016 PQ Blackwell Limited www.pqblackwell.com
Japanese edition © 2016 PIE International Inc.
All image credits can be found on page 223.

All rights reserved. No part of this publication may be reproduced or
transmitted in any form or by any means, electronic or mechanical,
including photocopying, recording, or any information storage and retrieval systems,
without permission in writing from the publisher.

世界の美しい犬 101
101 Adorable Breeds Dogs
2016年12月11日　初版第1刷発行

　　　　　著者　　レイチェル・ヘイル・マッケナ
　　　　　監修　　山根義久（東京農工大学 名誉教授、公益財団法人 動物臨床医学研究所 理事長）
　　　　　装丁　　大島依提亜
　　　本文組版　　松村大輔（PIE Graphics）
　　　　　翻訳　　大浜千尋
　　日本版編集　　関田理恵

　　　　発行人　　三芳寛要
　　　　発行元　　株式会社パイ インターナショナル
　　　　　　　　　〒170-0005 東京都豊島区南大塚 2-32-4
　　　　　　　　　TEL 03-3944-3981 FAX 03-5395-4830
　　　　　　　　　sales@pie.co.jp
　　編集・制作　　PIE BOOKS
　　印刷・製本　　図書印刷株式会社

ISBN 978-4-7562-4842-8 C0072 Printed in Japan

本書の収録内容の無断転載・複写・複製等を禁じます。ご注文、乱丁・落丁本の交換等に関するお問い合わせは、小社ま
でご連絡ください。本書に掲載されている情報は、主に 2016 年 11 月までに集められた情報に基づいて編集しておりま
すので、出版までに変更されている場合がございます。また、掲載されてる情報につきましては諸説ある場合がございま
すので、あらかじめご了承ください。